Harry Hennings · Minolta Maxxum · Dynax 7xi

MINOLTA

International

DYNAX **7xi**

U.S.A.

MAXXUM **7xi**

HOVE FOTO BOOKS Harry Hennings

In U.S.A.
The Minolta Dynax 7xi is known as the
Maxxum 7xi

All text, illustrations and data apply to either of the above cameras

First English Edition September 1991
Published by Hove Foto Books
34 Church Road, Hove, Sussex BN3 2GJ

English Translation: Petra Kopp
Technical Editor: Colin Leftley
Production Editor: Georgina Fuller
Minolta Technical Advice: Bernard Petticrew
Typesetting & Layout: Annida's Written Page, Sussex BN43 5HH
Printed in Germany by Kosel GmbH, Kempten

British Library Cataloguing in Publication Data
Hennings, Harry
 Users guide to Minolta 7xi.
 1. Title
 771.32

 ISBN 0-906447-92-5

UK Distribution:

Newpro (UK) Ltd.
Old Sawmills Road
Faringdon, Oxon
SN7 7DS

Contents

Expert knowledge and artificial intelligence

Since the introduction of the Minolta 7000 in 1985 Minolta has been the trend-setter in the field of autofocus SLR photography. The Minolta Dynax 7xi is the first in the third generation of AF SLR cameras from Minolta. It combines the most advanced camera technology with modern design and comfortable handling.

The Dynax 7xi has features never before seen on an SLR camera. It is the first SLR camera to have expert intelligence and data processing based on fuzzy logic. With this camera, Minolta has made ambitious photography even easier and more versatile.

Once again, Minolta has produced a milestone in the development of camera technology. The control of the autofocus system, automatic exposure metering and new autofocus functions are based on the know-how of experienced photographers. In order to be able to respond to every photographic situation, with maximum precision as well as flexibility, the Dynax 7xi uses the most modern computer software currently available, based on fuzzy logic. The software analyses a wealth of camera and subject data, which forms the basis for the automatic setting of focus, exposure and focal length. Based on the data stored in its memory, the Minolta Dynax 7xi then makes decisions in a similar fashion to an experienced photographer.

One useful feature is the new type transparent LCD panel underneath the viewfinder screen, which offers additional displays to simplify the processes of creative photography.

Selecting functions and changing camera settings is made particularly simple by the dual control dial of the Dynax 7xi.

Minolta has developed as many as five new autofocus lenses, the 3500xi Program Flash unit, and four new expansion cards as basic accessories for its new generation of cameras.

With Minolta's introduction of the Dynax 7xi new terms like expert intelligence, expert autofocus, expert automatic exposure, expert autozoom system and, of course, the magic word in modern computer technology, fuzzy logic, make an appearance. What's behind all these catchwords?

Expert intelligence - In difficult photographic situations every photographer will, on at least one occasion, have longed for the advice of an expert. The computer brain of the Dynax 7xi contains knowledge that helps you to achieve outstanding results even with tricky tasks or unusual subjects. The camera automatically makes this knowledge available and the expert system of the camera, a sophisticated computer control system, makes its decision in a way similar to human thinking.

The Dynax 7xi analyses the subject viewed and the surrounding area, in a fraction of a second - computer experts call this real time. Based on its stored photographic know-how, the camera then automatically selects the focus, exposure and - new on the Dynax 7xi - the focal length that best suits the main subject and its surroundings. All specialist modes available for different subject situations on conventional AF SLR cameras have also been in-cluded in the expert system of the Minolta Dynax 7xi, which means that the camera can react precisely to nearly any photographic situation imaginable .

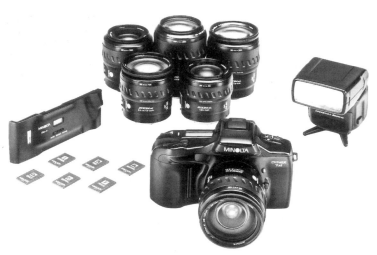

Five new zoom lenses, the 3500xi flash unit, six new expansion cards and a data back were launched at the same time as the Dynax 7xi. The accessory range is constantly being extended, and existing Dynax accessories can also be used with the Dynax 7xi.

Fuzzy logic control - Latest software developments ease the handling of the Dynax 7xi. Using fuzzy logic, the computer makes decisions in a way that is similar to human ways of thinking. Conventional computer logic will, for example, treat subjects which are two or more exposure values (EV) darker than the background as "backlit subjects". Brighter subjects, on the other hand, are considered "evenly lit". Even small variations of around 0.1EV (from 1.9 to 2.0EV, for example), will suddenly cause the camera to behave differently. Fuzzy logic ensures softer transitions in such situations because it is better at differentiating terms that are not clearly defined, such as "backlight". Another advantage of fuzzy logic is its data processing method, which makes the system substantially faster.

Expert autofocus - The new standard of autofocus photography Minolta has set with the Dynax 7xi is based on five years' experience with autofocus control systems in SLR cameras. The speed and versatility of this new system are so far unsurpassed.

The largest AF metering area ever on an SLR camera enables the Minolta Dynax 7xi to track even very fast movements

With the help of the expert knowledge stored, the autofocus system analyses the subject and automatically determines which of the four AF sensors covers the main subject. The four autofocus sensors are arranged in a cleverly devised pattern, and form an AF metering area three times larger than that of any other autofocus

camera. This makes picture composition a lot easier and following moving subjects has also become simpler, even when they constantly change direction.

Multi-directional predictive autofocus - The high calculating speed of the Dynax 7xi computer enables the camera to respond to many different types of subject movement, and to focus continuously. Conventional AF SLR cameras can only track subjects moving towards the photographer at a constant speed, but this is only one of many photographic situations. The Dynax 7xi can recognise even sudden changes in speed and direction of movement, and so its autofocusing can respond accordingly. It precisely calculates in advance the position of the subject at the moment of exposure.

High speed autofocus - Compared to the earlier cameras, the speed of the autofocus setting has also been improved on the Minolta Dynax 7xi. The camera's automatic focusing system can track very fast movements twice as fast as is possible with earlier models.

Expert automatic exposure - The new honeycomb exposure metering pattern of the Minolta 7xi is also a world first and forms the basis of a powerful expert automatic exposure system. The unusually large metering sensor, with as many as 14 segments, and the clever program for analysing the brightness distribution in the subject, ensures a very high exposure success rate, even in unusual lighting conditions. Minolta has played a leading role in the development of light metering equipment for industry and photography for many years, and the metering system of the Dynax 7xi benefits from Minolta's experience and knowledge in

AF-integrated honeycomb multi-pattern metering compares the brightness of 13 metering segments with that of the background. This sophisticated metering method guarantees optimum exposure in all light conditions.

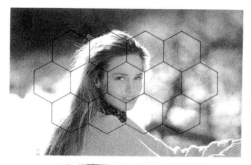

Main subject in the centre

Portrait format shot

Small main subject

The combination of autofocus and exposure metering automatically achieves an optimum exposure, regardless of the position of the main subject within the image section.

this area. The silicon photodiode comprises 13 metering segments arranged in a honeycomb pattern, plus a metering segment for the background. This enables the Minolta expert exposure system to adjust the sensitivity distribution to match the position of the main subject over a wider area. With the help of fuzzy logic, different brightnesses in the subject are related to one another, and the expert knowledge stored automatically balances the weighting of the different metering segments.

Expert program selection - The Dynax 7xi does not need special programs for different photographic situations. This is because the

expert exposure system automatically discriminates between land-scape and close-up shots, or between portrait and sports/action shots. On the basis of this knowledge, it automatically selects the shutter speed/aperture combination best suited to the subject and photographic situation.

Creative program control - Despite all this automation, the photographer can still intervene and change the camera's sugges-tion. To do this he only has to operate the front and rear control dials, allowing him to preselect any shutter speed or aperture setting. The Image Control Index at the lower edge of the view-finder image is also new and shows the effects of any adjustments made on the depth of field, or the sharpness of movement.

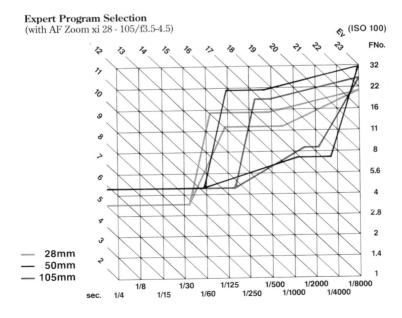

Expert Program Selection
(with AF Zoom xi 28 - 105/f3.5-4.5)

— 28mm
— 50mm
— 105mm

Xi series lenses and the expert autozoom system - Another feature of the Minolta 7xi is the automatic focal length adjustment of zoom lenses in the new xi series. These newly developed lenses have their own zoom motor and a microprocessor. Despite their relatively large focal length range, the five xi lenses are very compact and light. A Dynax 7xi with an xi zoom lens automatically suggests a focal length setting which would ensure a good balance between main subject and surroundings. Photographers can, of course, adjust this setting according to their own ideas at any time. But for snapshots and action shots the autozoom function has the advantage that no time is lost selecting the focal length.

Image size lock - The new lenses have a special function button which activates the image size lock. This function maintains the image size of a moving subject by automatically adjusting focal length. It will be particularly useful for fashion and sports photographers, but if you love lively portraits you will also quickly recognise the advantages of this feature.

Wide view mode - At the touch of a button the Minolta 7xi viewfinder will show a picture area extended to 150% until the shutter is released. This allows the photographer to take into account the surrounding area while preparing the shot. You can see what is going on around your subject, and whether or not anything is likely to affect the shot. Wide view mode can be useful for action or sports shots too, when you are waiting for a skier, runner or car to move into the frame.

Auto stand-by zoom - Fast reactions are the strength of the new Minolta Dynax 7xi. As soon as you take the camera to the eye, all the expert automatic systems are activated. Automatic focusing starts, the automatic exposure system checks the subject brightness, and the autozoom function of the xi lenses preselects a suitable focal length. All of this happens without the need to touch the shutter release button, making photography with the Minolta Dynax 7xi faster and more dynamic.

Integral flash unit - The Minolta Dynax is the only interchangeable lens AF SLR camera having an integral flash unit with a preflash function to reduce red eye. The tiny flash unit on the view-

finder housing automatically pops up when the expert exposure system realises that flash is needed to obtain correct exposure. When the red eye reduction flash is activated, the flash unit fires several weak flashes before it makes the actual exposure with the main flash. This causes the subject's pupils to contract, reducing the risk of red eye.

Program Flash 3500xi - The powerful 3500xi electronic flash unit is new to the Dynax range. It has a motorised zoom reflector that automatically adjusts the coverage angle to match focal lengths between 28mm and 105mm. The Minolta Dynax 7xi is also the first camera world-wide to allow wireless remote control of an external flash unit. The integral flash unit of the Dynax 7xi gives the start and stop signals for the off-camera flash unit.

Viewfinder image with unique graphic display - The transparent LCD display set underneath the viewfinder screen of the Minolta Dynax 7xi is so far unique. It displays data on any activated camera functions directly over the viewfinder image. All displays not currently in use are switched off.

New expansion cards - Along with the new Dynax 7xi Minolta has also introduced six new expansion cards to adapt the camera to tackle special tasks and for extending its functions. One special card serves for the individual programming of the Dynax 7xi. The other five were developed for travel and child photography, intervalometer control, depth of field control and for panning effects.

Data back - A data back, available as an extra, allows the imprint of date or time in the lower right-hand corner of pictures. The Data Back QD-7 is simply exchanged for the standard back cover.

Strong contrasts, as in this shot by Bernd Fiebig, are no problem for the sophisticated exposure metering system of the Dynax 7xi.

14

The Minolta Dynax 7xi is fully integrated into the existing Dynax accessory range, and all Minolta AF lenses can be used. But new functions offered by 7xi, like the image size lock, are only available with the new xi series zoom lenses.

The Minolta Dynax 7xi, with its many new functions, is undoubtedly another milestone of modern camera technology. But this camera is not content with simply increasing the number of successful shots per film by means of clever automatic control systems; its new photographic techniques offer new creative possibilities. The Dynax 7xi does not just make photography easier, it make it more versatile too.

Getting started

Despite its technical sophistication and automation, the Minolta Dynax 7xi is extremely easy to use, even for beginners. All you need to do is load the batteries and a film, slide the main switch to ON, and lift the camera to the eye. The camera will automatically select the optimum image size, set the exposure, pop up the integral flash unit if it's needed, and set the focus. If the subject is moving, the camera will automatically track focus, and the direction of the movement no longer matters. The subject stays sharp in the viewfinder no matter whether it is moving towards, or away from the photographer. Neither is parallel or angular movement important, just so long as it stays within the ultra-wide metering area of the Minolta Dynax 7xi.

But there's even more. The expert multi-dimensional predictive focus control of the Minolta Dynax 7xi can even calculate the precise path a subject will take from the time the shutter was released to the actual moment of exposure, and sets the focus accordingly. Even if you are not sure whether you or somebody else who used the camera might have changed any of the camera settings by mistake, you don't have to rack your brains or check the settings. A touch of the large square **P** button, positioned at the top of the camera to the left of the viewfinder housing, is enough to reset the Minolta Dynax 7xi to the standard program mode. Program mode is a particularly convenient and sure way to achieve successful shots. But if you decided on an advanced camera like the Dynax, you should find out as much as possible about all its features as soon as possible. You should fully familiarise yourself with the camera which will help you capture not just good, but exceptional photographs.

First preparations

Before you take your first photographs with the Minolta Dynax 7xi you should spend time getting to know more about the functions of the different controls. Although the expert system of the Minolta

Dynax 7xi will carry out even the most unusual tasks, the photographer still needs to be able to tell it what he wants.

Battery loading - In order to get the camera ready to shoot, you first need to supply the power needed by its many electronic systems. The Minolta Dynax 7xi gets the power for its camera functions and for the zoom motor in the xi lenses from a 6-volt 2CR5 lithium battery. The battery should only be inserted or changed when the camera is switched off, which means that the main switch has to be set to **LOCK**. The battery chamber is located in the grip of the camera and the battery chamber cover on the underside automatically pops open when the lock switch is pushed back. Fortunately, the arrow on the cover indicates the correct direction.

Four symbols give information on the charging state of the battery. The battery condition indicator appears whenever the main switch of the camera is set to **ON**. If the indicator is not visible, you need to check whether a battery has been inserted, or whether it has been inserted incorrectly. A fresh lithium battery is sufficient for about 30 to 35 films of 36 exposures if the integral flash unit is not used. These figures are based only on experience and therefore just guidelines. The exact number of exposures possible with one battery will depend on how the camera is used; how often the zoom motor is used, how heavily the AF motor is used, whether fast shot sequences were taken, or whether the photographer has played around a lot without pressing the shutter release button. All these factors affect the life-span of the battery. The amount of time a battery has been stored on the shelf will also affect its performance.

Compared to other types of batteries, lithium batteries are very resistant to low temperatures. But they, too, deteriorate when used in cold temperatures for longer periods. It is therefore advisable to store batteries in a warm interior pocket for long periods between shots. Batteries which have deteriorated because of cold conditions can recover in normal temperatures and should therefore not be disposed of immediately.

For special effects, such as backlit shots with graphic silhouette effects, the automatic exposure system of the Dynax 7xi can either be adjusted by a compensation factor, or the exposure can be selected manually.

Once the cover of the battery chamber has been opened, the battery is inserted with its contacts facing forwards.

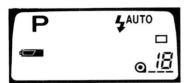

The fully-charged battery symbol appears for four seconds after the camera has been switched on.

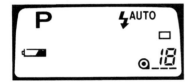

The low battery symbol appears for four seconds after the camera has been switched on.

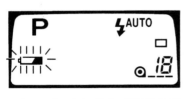

The low battery symbol appears with other displays, flashing constantly.

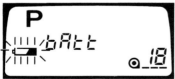

The weak battery charge symbol flashes, the letters **bATT** appear, or the data panel remains blank; the shutter release button does not respond.

Some parts brightly lit, others in deep shade - the honeycomb multi-pattern metering system of the Minolta Dynax 7xi copes automatically.

Batteries contain substances which are harmful to the environment, so please don't throw them in with normal household waste. It's better to give used batteries to your photographic dealer, who will dispose of them safely, or you can put them in special hazardous waste collections. Most people already know that lithium batteries cannot be recharged, and that they must never be thrown on fires because they can explode and give off toxic fumes.

The electronic circuits may very occasionally switch off and no display indications will be visible, although a new battery has been inserted into the camera. If this happens, you need to take the battery out and re-insert it. The display indications will reappear.

Film loading - Once the power supply is taken care of by inserting the battery, you can load the first film and start taking photographs. The automatic program will enable you to take technically sound shots immediately. But if you can't remember whether the camera settings have been changed, simply press the **P** button before the first shot to reset the camera to its standard settings. Before loading the film you need to open the back cover by pushing the back cover release on the left-hand side downwards. If you have used the camera before it is advisable to check the film window in the back cover and if a film is in the camera, the film window will show the total number of frames. The data panel at the top of the camera will show the number of frames exposed above the film cassette symbol. The number of exposures remaining is the difference between those two figures.

If there is no film in the camera, the film is inserted into the cassette chamber after opening the back cover and the film leader needs to be pulled along the guide tracks until it reaches the red marking at the lower right-hand side. The automatic film threading mechanism, and the integral motordrive, will automatically transport the film to the first frame once the back cover is closed. Although film loading should present hardly any problems, even experienced photographers occasionally touch and damage the very delicate shutter curtain by mistake. Because of this, the simple process of film loading needs to be done very carefully.

One side of the subject in the sun, the other in the shade - the expert automatic exposure system with fuzzy logic control has compensated automatically.

Film loading

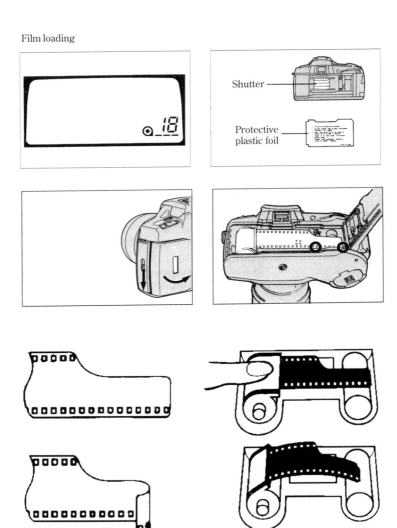

Shutter

Protective plastic foil

Film loading is particularly easy with the Dynax 7xi. Be sure to remove the protective plastic film from the film pressure plate the first time you load a film; the delicate shutter blades must never be touched. The film has to lie flat, it must not have any slack, nor must the film leader be bent.

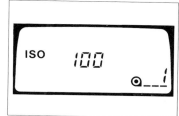

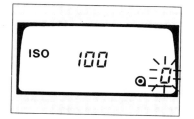

When the back cover is closed, the film is automatically wound to the first frame. If an **0** is flashing on the data panel, the film has to be reloaded.

On DX-coded films the film speed is set automatically, in a range between ISO 24/15° and ISO 5000/38°.

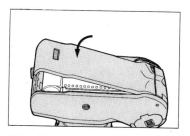

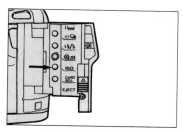

If the film speed is to be set manually, either because the film has no DX-coding or because it is to be exposed at a different speed, the **ISO** button inside the card door has to be pressed after closing the back cover. The speed can then be set with the front or rear control dial.

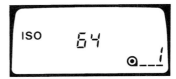

The film speed that has been selected manually with the front or rear control dial is confirmed by pressing the shutter release button half-way.

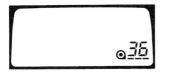

The exposed film is automatically re-wound if the Dynax 7xi is programmed accordingly.

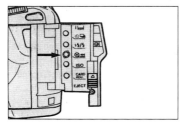

Motorized film rewind can be activated manually at any time via the specially protected button inside the card door.

The old adage that you should keep your back to the sun when loading a film still applies. Most people won't have had any problems with loading a film in direct sunlight, but the cassette slot may not be completely light-tight, which may allow several shots to get fogged. This only happens rarely, but this doesn't help you when it happens.

If the film has been inserted correctly, the LCD panel will show the film speed recognised by the camera, and a **1** for the first frame, for around four seconds after the back cover has been closed.

The camera recognises DX-coded films between ISO 25/15° and ISO 5000/38°. For non-DX coded films, or if the film is to be

exposed at a different speed, this can also be set manually. To do this, open the card door and press the **ISO** button on the inside. Use either of the two control dials at the top of the camera to set the speed in one-third increments in a range between ISO 6/9° and ISO 6400/39°. The selected value is confirmed by pressing the **ISO** button once more. But this confirmation is not necessary because the camera computer automatically takes on the selected value after four seconds. If you press the **ISO** button to check the selected value afterwards, the current value is confirmed in the data panel.

Film rewind takes place automatically at the end of the film. But the Customized Function Card xi allows the Minolta Dynax 7xi to be programmed so that film rewinding has to be activated manually. The card also allows the camera to be programmed so that the film tip is not wound right back into the cassette - useful if a partially exposed film needs to be re-loaded. In order to rewind a partially exposed film early, or to manually activate the rewind process at the end of the film, you need to press the rewind button inside the card door. This button is indented to prevent accidental film rewinding too early.

Note: 72-exposure films and Polaroid films cannot be used in the Dynax 7xi.

First shots - The battery is inserted, the film loaded, the main switch set to **ON**, the **P** button has been pressed to reset the automatic program in case anybody has been playing with the button. You're ready to shoot. As soon as you touch the sensor bar on the grip - which happens automatically if you hold the camera correctly - the sensors on the viewfinder eyepiece are also switched on. These also activate the automatic exposure and autofocus systems and the autozoom function, as soon as the camera is held to the eye. Take the camera away and the sensor switches off the autofocus and automatic exposure systems after four seconds.

If the program reset button has been pressed, the camera works in the standard setting using automatic program, honeycomb multi-pattern metering, autofocusing, single frame shooting, the wide AF metering area and with automatic flash cut-in with adverse lighting. The Customized Function Card xi can be used to change many of the standard settings of the camera according to individual preferences and needs, but more on this later.

In P mode the shutter can be released at any time, as soon as framing is right and correct focus is confirmed by the viewfinder indicator. The advanced technology of the Minolta Dynax 7xi automatically ensures a technically sound shot.

But before you take your first pictures, here are a few tips for beginners about holding the camera correctly. Many people may find these tips banal and superfluous, but experience has shown that thanks to modern control technology, most imperfect shots these days are caused by poor camera handling. Skip the following paragraphs if you've been taking photographs for some time.

Hold the camera firmly by its grip so that you are touching the sensor bar with the fingers of your right hand. Grip the zoom ring of the lens from underneath with your left hand, and support the camera body with your palm. To keep the camera steady, press your elbows firmly against your chest and the camera against your face.

For security reasons it is advisable to put the carrying strap around your neck or wind it around your hand. It would be a shame if your expensive camera slipped out of your hand. It is also important that you don't hold onto the motor-driven parts of the lens - the focusing ring on the standard AF lenses or the front part of the new xi lenses. Beginners may accidentally cover the AF illuminator of the camera with the fingers of the right hand, in which case autofocusing can't work properly in difficult lighting conditions.

Operating controls

Before describing in detail advanced techniques in using the Minolta Dynax 7xi, and explaining their uses for creative photography, the following pages describe the controls of the camera for people who don't yet own a Dynax, or who found the information in the instructions manual too brief. There are plenty of differences between the Dynax 7xi and its predecessors, the Minolta 7000 and Minolta 7000i. All the new functions require a different design, made most obvious from outside by the data panel which has been reduced in size because it has become less important.

Main switch - To activate camera functions the main switch of the Minolta Dynax 7xi has to be pushed from the **LOCK** to the **ON** position. This activates the sensor bar on the camera grip, which in turn causes the sensors on the viewfinder eyepiece to go into standby mode. As a result, when you look through the viewfinder, the camera automatically preselects all the standard settings such as framing, focus and exposure. With previous models, these functions were not activated until the shutter release button was pressed half-way, but the Minolta Dynax 7xi is ready to shoot as soon as your finger touches the shutter release button.

Program reset button - The Minolta Dynax 7xi is set to program mode when the program reset button is pressed. Any earlier settings are cancelled, except the individual settings selected with the Customized Function Card xi. The camera takes photographs in program mode, with honeycomb multi-pattern metering, autofocusing using the wide metering area, single frame mode, and automatic flash cuts in under adverse lighting conditions.

Shutter release button - Thanks to the ergonomically formed grip moulded into the right-hand side of the top of the camera, the tip of the index finger automatically comes to rest on the shutter release button. The shutter release button does not normally have to be touched to activate autofocus, automatic exposure control and the autozoom function. This is only necessary if the sensor bar on the

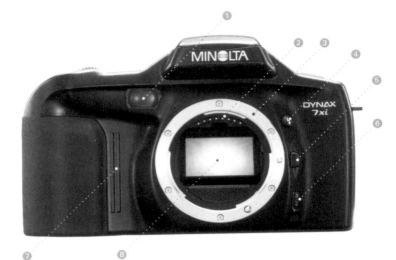

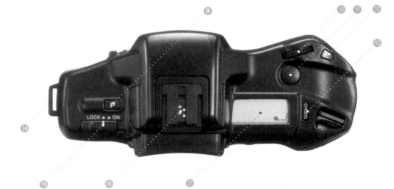

1. AF illuminator
2. Lens contacts
3. Bayonet index
4. Flash pop-up button
5. Lens release
6. Focus mode switch
7. Grip sensor
8. Mirror
9. Program reset button
10. Front control dial

11. Shutter release button
12. Viewfinder mode selector
13. Card on/off button
14. Carrying strap eyelet
15. Main switch
16. Accessory shoe
17. Data panel

grip is not touched. When taking shots you should make sure the shutter release button is pressed in a steady, smooth movement. Any jerking can lead to camera shake.

Front control dial - The dual control dials make the operation of the Minolta Dynax 7xi a lot easier. The vertically set front control dial at the top of the camera, directly in front of the shutter release button, enables the photographer to easily override the automatic exposure process at any time. This dial is used to switch from standard P mode to PS mode and is used together with the dial-function selector (**FUNC**) to set the exposure program. If the **FUNC** button is pressed once, the **MODE** indicator appears in the viewfinder display and the front control dial can then be used to select P mode, shutter speed priority (S), manual exposure control or aperture priority (A). In shutter-priority and manual exposure mode the front dial controls the shutter speed. The **Bulb** function for slow exposures is also selected in this way.

If the **FUNC** button on the back of the camera is pressed twice, each of the sensors in the wide AF metering area can be used individually as the target areas for focusing. Once the flash mode button inside the card door has been pressed, the flash function is also selected by means of the control dial. And the film transport

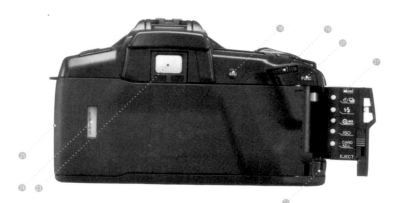

18. AE lock button
19. Rear control dial
20. Dial function selector
21. Card door

22. Remote control contacts
23. Viewfinder eyepiece
24. Film window
25. Back cover release

31

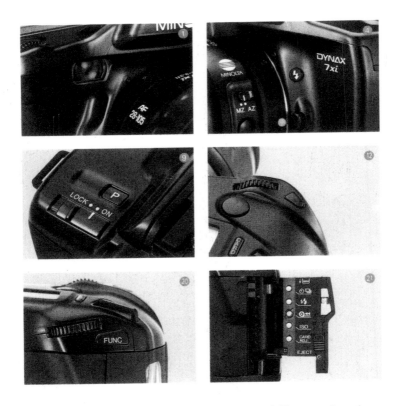

function and self-timer, as well as the manual film speed setting, are activated with the front control dial in conjunction with the corresponding button inside the card door.

Rear control dial - The rear control dial can be used instead of the front control dial to select the functions in conjunction with the buttons inside the card door. But some options can only be selected with the rear control dial, like selecting the aperture in aperture-priority or manual exposure mode. If the **FUNC** button is pressed twice, the rear control dial can be used for switching between the different methods of exposure measurement, either honeycomb multi-pattern metering or spot metering. The selection of the exposure compensation is also carried out with the rear control dial after pressing the **FUNC** button once.

The Dynax 7xi has an AF illuminator (1) for automatic focusing in low light or complete darkness. The flash pop-up button (4) allows the integral flash unit to be switched on at any time. When touched, the grip sensor (7) activates the electronic system of the camera.

The program reset button (9) cancels all manual settings and resets the camera to fully automatic mode. The wide AF area is selected by pressing the button next to the front control dial (12). The AE lock button stores the exposure data. Pressing the **FUNC** button (20) enables the selection of functions with the control dials. The buttons inside the card door (21) are used to select special functions. The viewfinder eyepiece (23) allows a maximum distance of 19mm between eye and viewfinder.

Viewfinder mode selector - This button is one of the special features of the Minolta Dynax 7xi. It extends the view so that the photographer can see the immediate area surrounding the subject. If the viewfinder mode selector button is pressed, the camera automatically selects a shorter focal length in order to show a wider image section. The **WIDE** indicator will also appear in the viewfinder display, as well as brackets indicating the area actually framed. If the shutter button is pressed, the lens returns to the focal length needed to frame the subject correctly. This function is only available with lenses in the xi series and, of course, is limited by the wide-angle range of the zoom lens used. No power zoom can show a wider angle of view if it is already in its shortest focal length setting! The wide viewfinder mode is switched off by pressing the button once again.

Card on/off button - The **CARD** button is located directly next to the data panel at the top of the Minolta Dynax 7xi. This activates the transmission of expansion card data to the computer control system of the camera and calls up the special functions of the expansion card installed. Pressing the button once again cancels the card.

Dial-function selector - The dial-function selector marked **FUNC** is used to prepare certain camera settings. If the button is pressed once, the front control dial can be used to select the exposure program, the rear control dial to select exposure compensation. The graphic display of the viewfinder shows which function is selected with which dial. If the dial-function selector is pressed twice, the front control dial is used to select one of the four AF sensors and use it as the AF target area, and the rear control dial is used to change between metering methods.

AE lock button - If the exposure reading is to be stored independently from the autofocus setting, you need to aim the camera at the relevant part of the subject and then press the AE lock button (**AEL**). You then compose with the AE lock button still pressed. As soon as you release the AE lock button the exposure metering system carries on working normally.

If an additional flash unit is used, the AE lock button can be pressed to fire a test flash and is also needed for slow sync flash photography. Once the subject has been framed as desired, and focusing is complete, the AE lock button is pressed and held down until the slow exposure has ended. For photographs using wireless remote flash control the AE lock button is pressed to fire a test flash from the external flash unit.

Grip sensor - The electronic system of the camera is switched on as soon as the grip sensor at the front of the camera is touched. Then sensors on the viewfinder eyepiece switch on the camera as soon as it is held to the eye. If the grip sensor bar is not touched during composition, the shutter release button has to be pressed lightly to switch on autofocusing, the autozoom function and the automatic exposure system.

Flash pop-up button - The flash pop-up button at the front of the camera is marked with a flash symbol, and is used to pop up the integral flash unit manually. But the camera will only fire a flash if it thinks necessary. If the flash is to be fired anyway, the flash pop-up button needs to be held down when the shutter is released. In aperture-priority, shutter-priority or manual exposure modes the flash only appears if the flash pop-up button is pressed. It does not fire in the creative programs PA or PS, even if it is up.

Lens release - The black button directly next to the bayonet and opposite the red marking on the lens is used to release the lens. If it is pressed, you can turn the lens to the left as far as it will go and then take it out of the camera bayonet.

Focus mode switch - The focus mode switch is used to switch conventional Minolta AF lenses to manual focusing mode. This is not necessary with the new lenses in the Minolta xi series. On these you only need to pull the focal length ring slightly back. Focusing then takes place in a similar way to changing the focal length, and the focus indicator in the viewfinder confirms when focusing is completed. The graphic display of the viewfinder indicates a switch to manual mode, with the **M.FOCUS** appearing at the lower right-hand side.

Back cover release - The slide switch sunk into the right-hand side of the camera is used to release the back cover which opens as soon as the switch is pushed down. To close the back cover, it only needs to be pressed lightly until it clicks shut.

Card door - A slide switch and five small white buttons are located on the inside of the card door.

The five buttons inside the card door are used to select film transport mode and self-timer, the flash function, to activate film rewind before the end of the film, for manual film speed selection and for activating card functions.

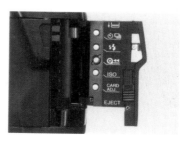

Card eject switch - The small black slide switch at the bottom right-hand edge of the card door is used to eject expansion cards from the card chamber.

Self-timer/drive mode button - The uppermost button inside the card door is used to switch between film transport functions and to select self-timer mode. The self-timer symbol appears on the data panel if this button is pressed once. If it is pressed once more, the camera switches to continuous advance mode with high frame frequency firing at up to four frames per second. A further touch of the button activates continuous advance with low frame frequency firing at up to two frames per second.

Flash mode button - Pressing the second button down inside the card door lets you select the flash function with the front control dial. Four settings are possible: you can switch off the flash unit completely; select single autoflash or single autoflash with pre-flash; or use the integral flash unit to give the signal for wireless remote TTL control of external flash units like the 3500xi.

Rewind button - The middle button inside the card door, the rewind button, is specially protected against accidental operation. This button is used to activate the rewind process manually and can also be used to rewind partially exposed films.

Film speed button - The film speed button activates the camera for manual film speed selection for non DX-coded films, or if DX-coded films are to be exposed at a different speed. By pressing the film speed button, both the front and the rear control dials of the

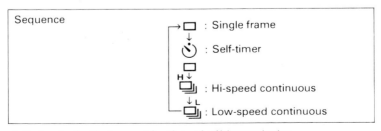

Indicators for the film transport function and self-timer activation.

Minolta Dynax 7xi can be operated to vary the film speed setting from ISO 6/9° to 6400/39° in one-third stop increments.

Card adjust button - The bottom button inside the card door is marked **CARD ADJ.** and allows the selection of the different expansion card options.

Body data panel

At a first glance "old" Dynax photographers will be disappointed with the data panel of the new Minolta Dynax 7xi. The large LCD panel, which was angled slightly towards the photographer, has been replaced by a noticeably smaller display that is no longer at an angle. There is an explanation for this. The angled display of the Dynax 7000i and 8000i was necessary in order to make the preliminary camera settings easier for the photographer. The Minolta

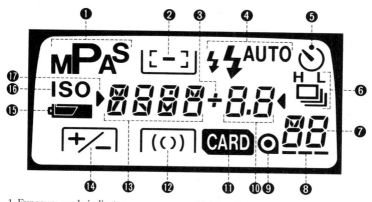

1. Exposure mode indicator
2. Wide/local focus indicator
3. Exposure compensation display
4. Flash mode indicator
5. Self-timer indicator
6. Drive mode indicator
7. Frame counter
8. Film transport signals
9. Film cartridge mark
10. Aperture/exposure compensation card setting displays
11. Card indicator

12. Metering mode indicator
13. Shutter speed/film speed/card name/AF local sensor displays
14. Exposure compensation reminder
15. Battery condition indicator
16. Film speed mark
17. Preselection indicator

Dynax 7xi decides on the necessary preliminary settings itself and actually controls them automatically. Adjustments are only necessary when the photographer has the camera held to the eye, and is not happy with the suggested exposure data. He can then respond very quickly, using the dual control dial system, and check any changes in the LCD or graphic viewfinder display. This renders superfluous the pleasantly angled data panel, we've come to appreciate in the earlier Dynax generation. But the data panel of the Dynax 7xi still provides all important data on operating modes and exposure. But not all the data is displayed simultaneously - the panel only shows the relevant data for the operating mode being used.

Exposure mode indicator - The indicator for the activated exposure control system appears in the top left-hand corner of the display panel:
- P - automatic program
- PA - creative program with aperture selection
- PS - creative program with shutter speed selection
- M - manual exposure control
- A - aperture-priority
- S - shutter-priority

Wide/local focus indicator - The AF metering area selected is shown at the top of the data panel next to the exposure mode indicator. This indicator only appears if the dial-function selector has been pressed twice. For the duration of the setting the local sensor activated is shown underneath the focus indicator, in place of the shutter speed. This disappears when the setting is complete, and the panel only shows whether the wide metering area or a local sensor is active. In order to find out which local sensor is activated, the indicator needs to be called up again by pressing the dial-function selector once more. The selected area will, however, be displayed on the viewfinder screen at all times.

If the rectangular frame appears on the panel, the camera is working with the wide AF metering area. A rectangular bar comes on when the camera has been switched to a local sensor.

Flash mode indicator - Four flash functions are available on the Minolta Dynax 7xi, and the selection made is permanently visible

at the top of the data panel. The flash symbol plus **AUTO** signals standard TTL flash control. Another smaller flash symbol in front of the first one shows that the pre-flash function for minimising red eye has been activated. **OFF** is displayed only when selecting flash function. In normal use, with flash off, nothing appears in this sector, and if both flash symbols are flashing, the integral flash unit of the Minolta Dynax 7xi is being used to give the signal for wireless remote TTL flash control of external xi flash units.

Self-timer indicator - The self-timer symbol in the top right-hand corner of the data panel indicates that the self-timer has been activated.

Film speed mark - The film speed is shown on the left-hand side of the second line of the data panel. This indicator appears only if the **ISO** button inside the card door is pressed.

Shutter speed display - The automatically or manually selected shutter speed is normally shown where the film speed is displayed if the **ISO** button is pressed.

Card name display - If an expansion card has been inserted into the card door, and the card adjust button has been pressed, the data panel displays the expansion card name instead of the shutter speed.

Exposure adjustment display - If exposure compensation is set, the compensation factor with a + or - symbol is shown in place of the aperture display, when called up using the dial-function selector.

Aperture display - The aperture display appears on the data panel directly to the right of the shutter speed display. This field is also used to indicate exposure compensation and to show the card setting.

Card setting display - The card setting display is only shown if the card adjust button inside the card door has been pressed. It takes the place of the standard aperture display.

Drive mode indicator - The film transport function is shown on the extreme right of the middle line of the data panel. A rectangle

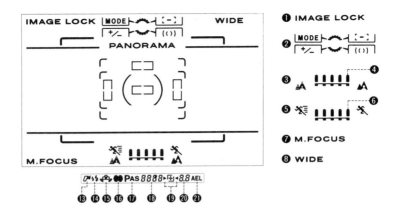

1. Image lock indicator
2. Dial function indicator
3. Depth index
4. Depth index symbol
5. Action index
6. Action index symbol
7. Manual focus indicator (M.FOCUS)
8. Wide view indicator
9. Image section brackets
10. AF metering areas indicators
11. AF local sensor indicators
12. Spot metering brackets
13. Flash-on indicator

14. Flash mode/flash-ready indicator
15. Camera shake warning
16. Focus signal
17. Exposure mode indicator
18. Shutter speed/film speed indicator
19. Exposure signals/exposure compensation indicator
20. Aperture display/exposure compensation factor
21. AEL indicator

symbolises single frame mode. Several stacked rectangles with the letter **H** above them indicate that high-speed continuous advance has been selected. If the letter **L** is displayed above the rectangles, the camera is set to continuous advance at up to 2fps. These indicators are permanently visible.

40

Battery condition indicator - The condition of the battery is displayed on the data panel for around four seconds every time the camera is switched on. There are two symbols, one for a fully charged battery, another for a weak battery. The battery needs to be changed if the weak battery symbol starts flashing. If the indication **bATT** appears next to the flashing battery symbol, the voltage is no longer sufficient for the camera to function correctly. This indicator does not appear if there is no battery in the camera.

Preselection indicators - A small triangle to the left of the shutter speed display and another to the right of the aperture display indicate which parameter can be varied by means of the control dial. These triangles should not be confused with those in the LCD panel in the viewfinder, which indicate any exposure deviation from the preselected exposure

Exposure adjustment reminder - In the left-hand corner of the data panel a + and - sign in a rectangle which is open at the bottom reminds the photographer that an exposure compensation has been selected. The compensation factor itself only appears on the panel if called up by means of the dial-function selector.

Metering mode indicator - The spot metering indicator only appears in the centre at the bottom of the data panel if the camera has been switched from honeycomb multi-pattern metering to spot metering.

Card indicator - If the special functions of an expansion card have been input and activated by pressing the **CARD** button, a black bar with the indication **CARD** appears as the third item of the bottom line of the data panel.

Film cartridge mark and transport signals - The film symbol on the bottom right-hand side of the data panel indicates that a film has been loaded. The film has been rewound if the symbol is flashing. The back cover can now be opened.

Frame counter - The frame number of the next exposure appears to the right of the film symbol. The film has not been loaded correctly if a **0** flashes. This means that the back cover must be opened and the film re-loaded correctly.

Graphic display viewfinder

The Minolta Dynax 7xi is the first camera to have graphic display indicators. Located underneath the viewfinder screen, they blend into the viewfinder image. Once again, the display only provides the information necessary for using a particular camera function, and this keeps things simple. The data is faded in by means of a completely transparent LCD screen underneath the viewfinder screen, and when indicators are unused they leave no marks or shadows in the finder.

IMAGE LOCK - The indication **IMAGE LOCK** in blue letters in the top left-hand corner of the viewfinder's graphic display signals that the image size lock function has been activated. This function, only available with xi series lenses, allows a moving subject to be kept at the same size in the frame within the limits of the focal length range of the zoom lens. The camera automatically adjusts focal length to make this possible.

Dial-function indicator - If the **FUNC** button, or dial-function selector, of the Minolta Dynax 7xi is pressed once, the indications **MODE** and +/- are displayed in the centre at the top of the graphic display. Two jagged brackets next to these displays symbolise the front and rear control dials respectively. The exposure program can be selected with the front control dial. The selection is indicated underneath the viewfinder image in the data panel, as well as on the data panel at the top of the camera. The rear control dial (lower bracket on the graphic display) is used to input exposure compensation factors in 1/2-stop increments from +4 to -4EV.

Symbols to indicate that the measurement areas for autofocus and exposure metering are now adjustable, by turning front and rear dials, appear on the screen when the **FUNC** button is pressed. The actual individual AF sensor areas and spot metering area, only appear if you actually select them by turning the dials. The front control dial can now be used to select the appropriate local AF

Modern zoom lenses allow the optimum image section to be selected without changing the shooting position or the lens. The new xi lenses for the Dynax 7xi go so far as to suggest a suitable image section.

sensors within the wide metering area for autofocusing. The photographer is free to choose any one of the four sensors as the autofocusing target area, and the graphic display precisely marks the position of the activated sensors in the viewfinder image. The position is also indicated on the data panel. The wide AF metering area, which takes into account all four sensors on shots in the landscape format, is bordered by corner brackets enclosing an almost square oblong. For shots in portrait format, i.e. when the camera is held vertically, only the three central sensors are activated which means that the focus frame now encloses a long rectangle.

The rear control dial is now used for switching from honeycomb multi-pattern metering to spot metering. The switch is indicated on the graphic display by two segments of a circle which roughly indicate the metering area in the centre of the viewfinder. Once again the change is also indicated in the data panel on top of the camera.

Wide view indicator - Wide view mode has been activated if the indication **WIDE** appears in the top right-hand corner of the viewfinder graphic display. The brackets enclosing the actual image recorded on film appear simultaneously.

M.FOCUS - The **M.FOCUS** indicator becomes visible in the bottom left-hand corner of the graphic display if the camera is switched to manual focusing. The same indicator appears if an xi series lens has been switched to **MZ** (manual zoom).

Image control index indicators - The new image control index indicators in the centre at the bottom of the graphic display are a useful new feature in the viewfinder of the Minolta Dynax 7xi. Depending on the activated exposure program, these indicators either show the depth of field or how subject movement is being affected by the shutter speed selected.

Normally a case for spot metering - but the honeycomb multi-pattern metering system of the Dynax 7xi can cope with lighting as subtly differentiated as this. If you don't trust the system, you can still switch to spot metering.

❏ **Depth index** - In automatic mode a scale of five indices appears, with a symbol for shallow and maximum depth of field at its left and right end respectively. An index mark indicates whether the background will be rendered in or out of focus. As the Dynax 7xi has no depth of field preview button, the depth index provides a useful guide for the image effect you'll obtain. The depth index can be switched off by pressing in the program reset button **P**, while pushing the main switch to **ON**. The index is switched back on in the same way. The depth index only appears in P, PA and A mode.

❏ **Action index** - The action index, too, is displayed as a scale with five indices and an index mark in the viewfinder graphic display. One symbol indicates blurred movement at the left end of the scale, another sharpness without blurring at the right end of the scale. Depending on the selected shutter speed, the photographer can use the scale to judge how great the danger of speed blur is, or whether the shutter speed is slow enough to create streaked effects in the shot. The action index appears in PS and S mode.

Panorama indicator - The indicators for the Panorama Format automatically appear in the graphic display of the camera if the panorama adapter is installed on the Minolta Dynax 7xi. A special viewfinder screen is therefore unnecessary.

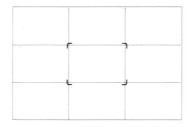

The brackets enclosing the metering area are also an excellent help for picture composition. In the landscape format they form the intersections of the lines dividing the image section into thirds.

The graphic display is a practical help for creating pictures as well. In the landscape format the brackets enclosing the wide AF metering area double as intersections for dividing the viewfinder screen into thirds, making a grid-type interchangeable focusing screen superfluous. According to the rules of the "golden mean",

46

your pictures will benefit if the main subject is near the intersections of the rules dividing the image area into thirds. But remember, when placing the main subject of a shot outside the wide metering area, you need to use the exposure lock as the AF sensors are located within this area.

Viewfinder data panel

An LCD panel with further viewfinder data is located underneath the viewfinder image. Like the graphic display, this additional data panel shows only what is necessary for the camera modes selected.

Flash-on indicator - A stylised flash unit appears on the extreme left of the panel if the integral flash unit has popped up automatically, or manually. This indicator also appears if a flash unit has been attached to the camera and switched on.

Flash mode indicator - The flash symbol gives the "flash ready" signal if the integral or an attached flash unit has been activated and is fully charged ready for use. At the same time, this symbol shows whether or not the red eye reduction flash has been activated. If it has, a small flash symbol appears in front of the larger one. The camera is ready for remote flash control if the small and large flash symbol blink alternately.

Camera shake warning - A camera symbol flashes if the subject brightness demands a shutter speed which is too slow for hand-held shots and could lead to camera shake. The camera automatically takes into account the current focal length setting, and the camera shake warning appears whenever the shutter speed is below the reciprocal of the focal length. This means that the warning appears in the viewfinder if the shutter speed is below 1/125sec at a zoom setting of 125mm.

The integral flash pops up automatically in these circumstances. If you want to take atmospheric shots with ambient light, you either need to use a tripod, or at least support the camera securely.

Focus signal - The electronic focus signal is also included on the data panel underneath the viewfinder image. The AF system of the

7xi starts to work as soon as the camera is activated by the viewfinder sensors or when pressing the shutter release button half-way. A dot enclosed by two brackets on either side appears when focusing with the multi-dimensional predictive focus control system has been completed. In focus lock mode the dot appears on its own, but autofocusing is not possible if dot and brackets are flashing. Here the shutter release button is locked.

Exposure mode indicator - The letters **P**, **PA**, **PS**, **A** and **S** on the data panel indicate the current exposure mode. Manual exposure mode is not indicated.

Shutter speed - The automatically or manually selected shutter speed appears next to the exposure mode indicator. If the film speed is selected manually, it can also be checked here, although this is a rather fussy business since the **ISO** button inside the card door has to be pressed first. The working range of the camera is exceeded if the slowest or fastest shutter speed is flashing which means you need to select a smaller or wider aperture.

Exposure adjustment indicator - If a +/- compensation has been selected, the relevant indication appears in a small square next to the shutter speed. As you enter the compensation setting, the selected factor appears in place of the aperture display.

Exposure signals - In manual exposure mode two small arrows indicate the direction in which the front and rear control dials need to be turned to adjust shutter speed and aperture. Whether the current selection would lead to under- or over-exposure (- or +), is shown in place of the exposure adjustment indicator. It is either too bright or too dark for a correct exposure if both triangles are flashing and the working range of the camera has been exceeded.

Aperture display - The two-digit aperture display is the penultimate indicator on the data panel underneath the viewfinder image. The display appears regardless of whether the aperture has been set manually or automatically. The working range of the camera has been exceeded if either the narrowest or the widest aperture is flashing. A slower or faster shutter speed needs to be selected.

AEL indicator - The AEL indicator on the extreme right of the data panel signals that the exposure metering setting has been stored using the AE lock button.

New technology

The expert system integrated into the computer control system of the Minolta Dynax 7xi draws on the extensive knowledge of the relevant photographic experts. The automatic camera control systems are programmed so that they reflect the response of such experts to any given photographic situation.

The expert system gives the camera the ability to analyse almost every subject situation and make judgments in almost human fashion. Minolta claims that the Dynax 7xi has been programmed with the knowledge and expertise of the best photographers worldwide. Perhaps this should be taken with a pinch of salt. But even so, the Minolta Dynax 7xi remains the most progressive camera world-wide at the time of writing. Also, anyone who has taken up photography will know that technically perfect shots don't necessarily guarantee good pictures. Automation inevitably leads to a standardisation of photographic technique, and many outstanding shots are achieved by actually rejecting these standards, or by breaking photographic rules. However, before you throw such rules overboard to create individual photographs, you need to know and understand the rules and their effects in the first place.

In this area the Minolta Dynax 7xi is a fantastic tool, and its integral artificial intelligence automatically makes all the preliminary settings necessary for producing a perfect shot. They are achieved by the time the photographer puts the camera to the eye. The convenient dual control dial system then allows you to immediately override the camera control system, and adjust settings to quickly put into practice your own ideas.

As soon as the Minolta Dynax 7xi is on the eye, it automatically analyses the part of the subject bounded by the frame. The autofocus system, for example, uses the subject's characteristics, the lens, and the camera position to determine which of the four CCD sensors registers the main subject, and how far away it is. It also works out if it is stationary, but if it is moving it calculates its speed and direction. The result of these calculations are fed into the exposure metering system, which in turn uses the results to determine the type of subject and the lighting conditions. The camera uses this data to calculate the sensitivity distribution of the

metering areas to expose precisely, and to arrive at a shutter speed and aperture combination suitable for the subject. If you are using the Dynax 7xi with one of the new xi series autozoom lenses, the expert system also controls the focal length setting and the zoom speed. No other autofocus SLR camera before the Minolta Dynax 7xi could boast such complex metering and control technology.

Fuzzy logic control

Fuzzy logic, the magic word of modern computer technology, is basically old hat. It was developed by Professor Lofti A. Zadeh, a computer scientist at the University of California, back in the mid-60s. Fuzzy logic is based on the realisation that human thinking often can't be boiled down to the clear definitions needed by most digital computer processing systems. Conventional calculators work with the parameters "yes" or "no" and "true" or "false" expressed as a number code, fuzzy logic replaces these with a continuous description of every input variable. This enables a computer controlled by fuzzy logic to analyse situations more in common with human thinking, and to respond in a more subtle way.

The flexibility of fuzzy logic becomes obvious with the answer to the question "When is a subject backlit?". According to conventional Aristotelian logic the term "backlight" has to be defined precisely, as a difference in brightness between subject and background expressed in exposure values (-2EV, for example). But what happens if the difference between main subject and background is only metered at 1.9EV? Conventional logic no longer considers this subject backlit but will assume it is evenly lit.

Conventional exposure control systems would under-expose the main subject by two stops in such a case. Fuzzy logic, on the other hand, will recognise that the subject is "somewhat backlit" or "has a little less backlight than before" - and will decide that it is still dealing with a backlight situation.

If a system based on conventional logic were to deliver such results, it would need an exact definition and identification of each possible condition and every possible change in circumstances. The number of conditions to be analysed for a reaction increases exponentially with the precision of the system. This means a huge,

cumbersome databank has to be worked through by the system before every decision can be made

A fuzzy logic system uses a single, continuous description for each of its input variables and can therefore compress this databank to a few simple rules. The rules can be analysed and compared more quickly.

No matter how finely graded a digital system may be, it will never really work continuously. It will, for example, react very abruptly to a slight change in conditions if this change means that the dividing line between two rules is crossed. A fuzzy logic control system, on the other hand, responds to small input changes with appropriately small changes in its output. The result is a smooth, continuous control system and a degree of flexibility that cannot be achieved with a conventional approach.

Fuzzy logic control is used in the Minolta Dynax 7xi for the following functions:

❒ Determining the position of the main subject within the AF metering area (automatic subject recognition)

❒ Selecting the metering pattern and adjusting the weighting (autofocus-integrated honeycomb multi-pattern metering in 14 segments)

❒ Setting shutter speed and aperture (expert program selection)

❒ Continuous speed control of the zoom motor (focal length control).

Expert autofocus

Since the introduction of the Minolta 7000 (the first autofocus SLR camera with body-integral autofocus) more than five years ago, Minolta has continued to set trends and new standards in the field of autofocus technology. With the AF system of the Dynax 7xi, the Japanese have once again exceeded what was once thought possible. The expert autofocus of the Minolta Dynax 7xi is by far the

most versatile and progressive autofocus system currently on the market.

New AF module - At the heart of the expert autofocus system of the Minolta Dynax 7xi is its new AF module. It consists of four extremely sensitive, high-resolution CCD sensors (charge coupled devices) with a total of 836 elements. The high sensitivity of the sensors allows precise autofocusing even in low light. The automatic focusing system of the Dynax 7xi will still work perfectly even at -1EV and with low subject contrast.

Wide AF metering area - The four sensors of the AF module are arranged in such a way that they capture the most important parts of the main subject in most situations. At 9x12mm, the metering area is three times larger than that of conventional AF SLR cameras. On the one hand this eases the tracking of moving subjects, and on the other, it allows more creative flexibility. When changing from landscape to portrait format, the upper horizontal sensor is automatically switched off to make the autofocus metering area more suitable for subjects using the portrait format. The change from portrait to landscape format is registered by a special position sensor in the Dynax 7xi which is fed into the AF system. The focusing area brackets in the viewfinder graphic display automatically show the size of the current focusing area.

Automatic subject recognition - If the local sensors meter different distances, fuzzy logic lets the expert autofocus system calculate very quickly in which metering area the main subject is found and where maximum sharpness is required. Apart from the distance, the calculation also accounts for focal length setting and camera position.

High speed autofocus - Thanks to new technology in camera hardware and development, the expert autofocus system of the Dynax 7xi could be made twice as fast as conventional systems. The speed of data processing has been increased substantially by using a 16-bit microprocessor with a frequency of 20MHz, and special algorithms for tracking fast-moving subjects. This means that the autofocusing can make more measurements per second, and the position of the subject can be tracked almost in real time. An

Minolta Dynax 7xi autofocus sensor module (exploded view)

1. Infra-red block filter
2. Collector element
3. Diverting mirror
4. Dividing mask
5. Divider optics
6. CCD line sensors

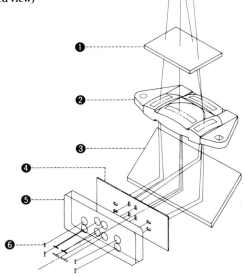

Minolta Dynax 7xi - AF metering area and local sensors

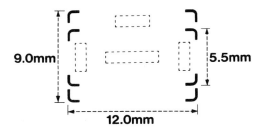

9.0mm 5.5mm

12.0mm

Position markings for AF local sensors and AF metering area in the viewfinder of the camera.
Portrait format: AF metering area = 9x12mm
Landscape format: AF metering area = 5.5x12mm

54

additional increase in autofocus speed has been achieved with a newly developed motor with a faster response and a higher number of revolutions per minute.

Multi-dimensional predictive focus control - The predictive autofocus was one of the great advantages of the Dynax 7000i and 8000i. The Minolta engineers have improved it once again. On the Dynax 7xi the position of a moving subject is calculated three times faster than on conventional autofocus SLR cameras. As the

Multi-directional predictive autofocus

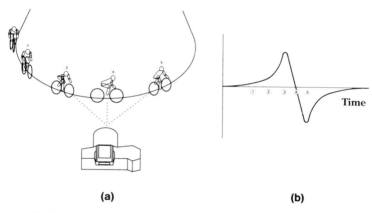

(a) **(b)**

If a subject is moving in front of the camera in a U-shape (a), the relative speed at which it is moving towards, or away from, the camera is constantly changing (b)*. The Dynax 7xi is able to recognize these changes, follow them and predict the distance at the point of exposure.

* shows the rate of change in the film plane

(1) and (2): The rate of change in the film plane increases while the subject is approaching the camera.

(3): The rate of change reaches its maximum when the subject is moving directly towards the camera.

(4): When the subject is moving in parallel with the film plane the rate of change (change in the distance from the camera) is reduced to zero.

(5): Once the subject has passed point (4) and is moving away from the camera, the rate of change in the film plane becomes negative.

data is processed more quickly, the camera can also respond to different directions and types of movement.

Most autofocus systems can only track subjects moving directly towards, or away from the camera at a constant speed. As its data processor works with very subtle differentiations, the Dynax 7xi can determine whether a subject is speeding up or slowing down, whether it is moving across the shot, or changing direction. The camera always selects the algorithm which applies to the type of movement recognised. This is why the Dynax can calculate, after the shutter has been released, where a subject moving erratically will be when the shutter opens.

Three-dimensional subject tracking - The expert autofocus of the Minolta Dynax 7xi is not just able to determine the speed of subjects moving directly towards, or away from, the camera. It can also calculate acceleration in all three dimensions. The central computer of the Minolta Dynax 7xi uses this data to determine the most suitable shutter speed/aperture combination for the current subject, to calculate the position of a subject, and to control the action index showing how great the danger of speed blur is.

Autofocus illuminator - The Minolta Dynax 7xi is able to focus automatically even in complete darkness, or with low subject contrast. To do this, it is equipped with an integral AF illuminator which projects a pattern of dark red lines onto the subject that can be used for automatic focusing by the AF system of the camera. In low light it is important not to cover the red light projector next to the handgrip.

In low light or low contrast, the AF illuminator is activated if a lens up to and including 300mm is attached (longer focal lengths could not see enough pattern to be of use). However, the AF illuminator is not activated with the 300mm, f/2.8 Apo or 3X-1X Macro, even though they fall within the right focal length, because these lenses would physically block the beam. Also, in the case of the 3X-1X, the beam would not be pointing at the subject anyway.

Manual selection of the AF metering area - Although the wide metering area with the four sensors is required for many AF functions, each of the AF sensors can also be used on its own as a target area for autofocusing. The local metering areas are selected

The AF metering area automatically changes when the camera position changes from landscape to portrait format.

If the main subject is outside the brackets enclosing the wide AF metering area, the shot should be taken with focus lock. To do this, the main subject needs to be placed within the metering area and the shutter release button pressed half-way whilst the image section is selected.

with the front control dial by pressing the **FUNC** button below the rear control dial on the back of the camera. Their position is shown by rectangles in the viewfinder graphic display but the corresponding indicator on the data panel is only visible while the adjustment is made. Afterwards, the panel only shows whether the wide focusing area or a local sensor is activated.

Two of the four AF sensors are ranged vertically, the other two horizontally. All four sensors are switched on for shots in the landscape format, when the camera is held horizontally. When changing to portrait format, the metering area automatically adapts to the new conditions and switches off the uppermost horizontal AF sensor.

At a first glance focusing with local sensors may appear superfluous because it means that a number of special functions of the

The camera shake warning appears in the viewfinder if the subject is too dark for hand-held shots.

Minolta Dynax 7xi are unavailable. But it doesn't work quite like that. A local sensor is particularly useful when you want to focus from a precise area. Macro shots are a good example, where the depth of field is often only a few millimetres, and a local focusing area can easily achieve optimum sharpness without changing camera position or working with the focus lock.

The Minolta Dynax 7xi works with focus priority. This means that no matter which autofocus function is active, it will only release the shutter when the focusing process of the lens has been completed.

The focus signal in the viewfinder indicates that focusing has been completed. It also shows whether the AF system is working with autofocus tracking or focus lock. The autofocus control system of the Minolta Dynax 7xi automatically switches modes when it registers that a subject is moving from a still position. If the focus signal is flashing, the camera cannot focus. This signal is not visible whilst focusing is taking place, but if the shutter release button is pressed half-way, the focus is locked. The focus lock becomes necessary if the main subject lies outside the wide metering area, or the activated target area of a local sensor.

(◉)	Focus indicator

(◉)	autofocus tracking/focus signal
●	focus locked
()/● (blinkt)	(flashing) focus cannot be confirmed

The different focus indicators in the viewfinder.

What is important and new on the Minolta Dynax 7xi is that the AF system is activated the instant the camera is on the eye. This is called eye start automation.

The AF system only has to be activated by pressing the shutter release button half-way if the sensor bar on the handgrip is not being touched.

Manual focusing

Certain situations still benefit from manual focusing. The AF switch on the right underneath the bayonet needs to be pushed down in order to do this. The indication **M.FOCUS** appears in the bottom left-hand corner of the viewfinder graphic display. If you are using an xi lens, you need to pull the zoom ring towards the camera and turn it slightly in the direction the lens needs adjusting. In this case the adjustment is made by the motor in the lens and the focus signal appears on the data panel underneath the viewfinder image when focusing is completed.

Manual selection of the AF metering area

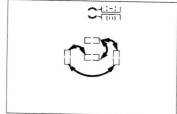

Each of the local sensors in the wide AF metering area can be selected as the AF target area by pressing the **FUNC** button and turning the front control dial.

If you are using a Minolta AF lens, you need to turn the focus ring until the subject becomes sharp in the viewfinder. The completion of focusing is also indicated by the focus signal.

The focus priority of the Minolta Dynax 7xi is deactivated in manual focusing mode, so the shutter can be released at any time. The image control index, too, is deactivated.

To resume AF mode, the autofocus switch needs to be pushed down once again. Autofocusing can also be resumed by pressing the program reset button, but this resets all other programmable camera functions to the standard setting at the same time.

Expert exposure metering system

Honeycomb multi-pattern metering - The Dynax 7xi carries out exposure metering by means of a metering sensor which divides the image area into 14 segments. The expert automatic exposure program allows the camera to recognise more subject types and lighting patterns than had ever been possible before. Coupled with the autofocus system, the honeycomb multi-pattern metering system has 13 metering segments arranged in a honeycomb pattern and a separate metering segment for the background. With the help of the fuzzy logic program, the distribution of the meter sensitivity of each of the 14 segments is based on a precise analysis of the subject. Data from the AF system, such as the position of the main subject, is also taken into account in determining optimum

AF-integrated honeycomb multi-pattern exposure metering with segments.

Position of the honeycomb metering segments in the image section.

exposure. Measurement of the different segments provides information on the brightness distribution, and to what extent the main subject is backlit, or perhaps lit by a spotlight. The computer of the Minolta Dynax 7xi uses this data to adapt the metering pattern and weighting to precisely suit the subject.

All calculations are carried out in real time and are constantly adapted to changing conditions. This means that the expert automatic exposure system is even able to track subject movements with the adopted sensitivity distribution.

The fuzzy logic control of the expert exposure system prevents sudden exposure jumps. The abrupt switching in and out of metering segments is avoided by means of the sensitive weighting

Control ranges of the expert program selection system for still and moving subjects at 55mm focal length (28-105mm,f/3.5-4.5 lens).

of the sensors. The analysis is then more subtly differentiated, and the overall exposure therefore more precise.

Spot metering - Apart from honeycomb multi-pattern metering, the Minolta Dynax 7xi also offers spot metering. This mode is selected with the rear control dial after the **FUNC** button has been pressed twice. The choice of metering methods is indicated in the graphic display of the viewfinder underneath the local focus symbol. If the camera is switched to spot metering, two brackets appear in the centre of the viewfinder to indicate the spot metering area. The selection is confirmed by pressing the shutter release button half-way, or the selection is automatically accepted by the camera after a delay of four seconds.

For spot metering you need to aim the spot metering area at the subject area which will give the optimum exposure, and press and hold the shutter release button half-way to store the metering result. You can then compose and if you don't touch the sensor bar on the handgrip during metering, you need to activate the exposure metering system by pressing the shutter release button half-way. Spot metering becomes a little more complicated if the focusing distance is different from the metering distance. In this case you first need to store the focus for the main subject before aiming the spot metering area at the area metered. You then need to store the exposure by pressing the AE lock button, compose, and finally release the shutter.

In order to return from spot metering to honeycomb multi-pattern metering, you either press the program reset button, or press the **FUNC** button twice and turn the rear control dial to the right or left by one step.

Pressing the program reset button has the disadvantage that all individual camera settings are also reset, cancelling, for example, any exposure compensation factors selected.

Manual exposure compensation - There are many reasons why photographers may wish to deviate from a technically correct exposure setting. Perhaps you want to expose your slides or negatives a little more tightly or generously in order to achieve a certain effect, or perhaps you prefer to push or pull your film.

On the Minolta Dynax 7xi you can select exposure compensation by +/-4 exposure values above or below the correct exposure. To set a compensation factor you need to press the **FUNC** button once. The exposure compensation symbol appears in the graphic display underneath the mode selection symbol. Compensation is selected with the rear control dial and shifts in 1/2-stop increments. The shutter release button is once again pressed half-way to confirm the selection, or the camera simply accepts it automatically after a delay of four seconds. Once the selection is confirmed, the compensation factor is no longer displayed, but the viewfinder and data panel indicate that compensation has been set. The data panel also shows whether the compensation factor is positive or negative. The compensation can be cancelled in the same way it was selected, or by pressing the program reset button. Using the **P** button does, once again, reset all camera functions to standard settings.

Exposure lock - The exposure and focus settings are normally stored together by the Minolta Dynax 7xi. But if you want to store the exposure separately from the AF system, you can select either spot or honeycomb multi-pattern metering, move in and meter a suitable part of the subject. You then press and hold the AE lock button until you trip the shutter release button. If you release the AE lock button earlier, the exposure system will once again work normally.

Expert exposure control

The new expert program selection system of the Dynax 7xi has removed the need for different programs for certain photographic situations. This is because these programs are already part and parcel of the automatic exposure control system.

With the Minolta Dynax 7xi the shutter speed/aperture combinations required for an optimum exposure are not selected from separate program graphs for different focal lengths. Instead, the camera works with a program zone which contains a wide range of correct exposure settings for every exposure value. The expert automatic exposure system recognises the differences between different photographic situations and adjusts the shutter speed/aperture combination to the conditions and the nature of each new subject.

In order to determine the type of subject, the expert program selection takes into account the movement of the subject in three dimensions, the distance and the reproduction ratio, as well as the focal length of the lens. Having analysed this data, the system is able to select the optimum exposure setting, no matter whether it is dealing with a landscape or portrait shot, an action shot, or any type of subject in between. If a subject is moving, for example, the expert program selection will try to select a shutter speed/aperture combination that can freeze the movement. If it is tackling a close-up shot, on the other hand, it will select a narrow aperture for maximum depth of field, and at the same time ensure that the shutter speed is fast enough for hand-holding without danger of camera shake.

The expert automatic exposure system is activated whenever the camera is used in the basic setting. If you want to return to this basic setting, you simply press the large **P** button at the left-hand side of the top of the camera. The shutter speed and aperture indicators on the body and viewfinder display panels will start flashing if the

The Minolta xi lenses are ideal travel companions. Thanks to automatic subject recognition and eye start automation you can take quick, inconspicuous snapshots in passing.

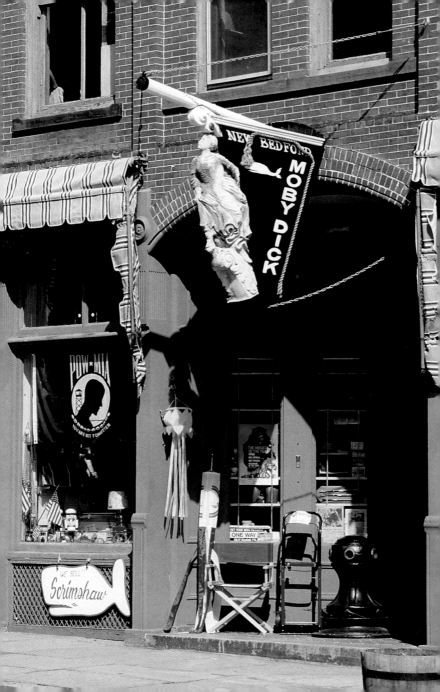

The aperture and shutter speed indicators will flash if the settings required for a correct exposure are outside the working range of the camera. If the triangular exposure signals are flashing, it is too bright or too dark for a correct exposure.

combination of camera and lens does not permit the correct settings. If the two triangular exposure signals in the viewfinder start flashing, it is either too bright or too dark for a correct exposure. If it is too dark, you need to use flash, whereas a neutral density filter may be able to help with over-bright subjects.

Creative exposure control

The photographer can accept or reject the suggestions given by the expert automatic exposure system of the Minolta Dynax 7xi. He can use his own specialist knowledge at any time using the dual control dial system which allows fast and easy adjustment of shutter speed and aperture.

The aperture is adjusted in half-stop increments by turning the rear control dial. The depth index on the graphic display at the bottom of the viewfinder image gives a rough idea of how changing the aperture will affect the depth of field.

The front control dial is used to adjust the shutter speed. In this case the camera compares every new shutter speed setting with the speed of the subject on the film plane. The action index appears

One subject, two shots. By using zoom lenses with focal length ranges between 35mm and 200mm such changes can be quickly done.

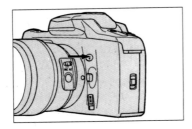

The camera switches to PA mode if the rear control dial is turned.

In P and PA mode the depth index provides a guide to the extent of the depth of field. If the aperture is changed by turning the rear control dial, the index moves to indicate the changed depth of field.

on the graphic display of the viewfinder, giving you some idea if the movement will be completely frozen or whether the photographer can expect a certain amount of blur.

In the PA creative program control the shutter speed is automatically adjusted to suit manual selection of the aperture setting. The shutter speed display will blink if the required speed is beyond the camera's range. If "8000" blinks, move the indicator to the right; if "30" blinks, move the indicator to the left. This is achieved by turning the rear control dial. If the two triangular exposure signals are flashing, the required settings are outside the working range of lens and camera.

PA and PS mode are not available if the camera has determined in P mode that flash light is needed. The automatic flash of the Minolta Dynax 7xi is switched off in both these modes, and the

Dramatic lighting, giving this portrait its powerful effect, is usually mastered without any problems by the honeycomb multi-pattern metering system of the Dynax 7xi. If you want to play safe you can switch to spot metering.
Photo: Rudolf Majonica

68

flash cannot be fired. The camera can only switch to PA or PS mode in this situation if it determines that there is enough light for an exposure without flash light, or if the flash is switched off.

The shutter speed can be manually set via the front control dial, in which case the aperture is automatically altered. The viewfinder graphic display shows the symbol for speed blur because the AF system of the camera constantly compares the changing settings with the measured subject speed at the film plane, and shows how shutter speed choice affects blur. In PS mode with preselection of a different shutter speed, the camera also switches back to the fully automatic P program after 30 seconds if no other camera control has been touched. The camera can also be reset manually by pressing the **P** button. If other settings are to be maintained, you have to switch back to program mode by pressing the flash mode button.

The smallest or largest aperture will flash in the viewfinder if the preselected shutter speed is too long or too short to give a correct exposure. If the triangular exposure signals in the viewfinder start flashing, it is either to bright or too dark. A grey filter can be used if it is too bright, but if the light is too dark, you need to return to program mode and use flash. You cannot flash in PS mode.

You can switch between the PS function with manual shutter speed adjustment and PA mode with manual aperture selection simply by turning the front or rear control dial. The camera switches to the PS function if you turn the front control dial, PA mode with the rear control dial.

The Minolta Dynax 7xi automatically switches back to fully automatic P mode if you don't touch any of the camera's operating controls for 30 seconds. Alternatively, you can also reset the

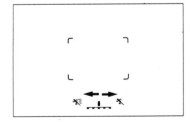

The action index appears if the front control dial is turned in P mode. It indicates the extent to which the selected shutter speed will reproduce a moving subject in focus or blurred.

camera by pressing the program reset button, but this also cancels every other camera setting. If you want to avoid this happening, just press the flash mode button to return to the P program.

If you find the depth and action indices distracting you can easily switch off. Simply press the program reset button whilst switching the camera on using the main switch. To switch the indices back on, simply repeat the process.

Aperture priority

Apart from expert program selection and expert creative program control, the Dynax 7xi does, of course, offer all the conventional exposure modes. These are selected by pressing the **FUNC** button on the back of the camera and turning the front control dial. The camera offers aperture- and shutter-priority mode, as well as manual mode. If you press the **FUNC** button, the viewfinder display shows the letters **MODE** and the front control dial symbol to the right. The exposure compensation symbol also appears underneath. If the front control dial is turned to the right, the camera first changes to aperture priority, then manual exposure control, shutter priority and finally comes back to P mode. If you turn the control dial in the opposite direction, the sequence is reversed.

The mode currently selected is shown both on the body data panel and the panel underneath the viewfinder image. You can confirm your selection by pressing the shutter release button half-way, but it's automatically accepted by the camera after four seconds. As usual, the camera is reset with the **P** button.

The depth index appears in the viewfinder graphic display in aperture-priority, PA and program and modes. It shows the depth of field for the current aperture setting in five steps. The index mark is on the extreme right of the scale to signal maximum depth of field and moves towards left to signal the reduction in the depth of field as the aperture is opened.

As in the creative PA program, the aperture setting is changed using the rear control dial, and each click of the dial changes the aperture by a 1/2 stop. Like the exposure mode, the manually selected aperture and shutter speed (automatically selected by the

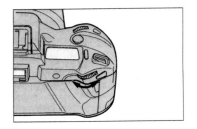 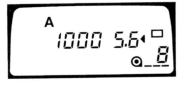

Aperture priority (A)

In aperture-priority mode (A) the aperture is pre-selected using the rear control dial; the camera automatically selects a suitable shutter speed to achieve a correct exposure. The automatically selected shutter speed as well as the manually selected aperture are shown in the viewfinder and on the body data panel.

camera to produce a correct exposure) are shown in the view-finder. A small triangle next to the aperture on the body data panel indicates that this setting has to be selected manually. The aperture range that is available depends on which lens is attached to the camera. The aperture has to be stopped down or widened to achieve a correct exposure if the slowest or fastest shutter speed is flashing in the viewfinder and on the body data panel. If it is too bright or too dark for a correct exposure, the triangular exposure signals in the viewfinder will start flashing. A neutral density filter can help if it is too bright, whereas flash or a faster lens is needed to combat low light.

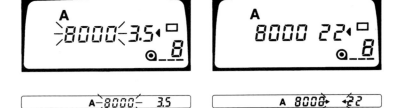

The number 8000 will flash in the viewfinder and on the body data panel if the fastest shutter speed is not fast enough to achieve a correct exposure. The diaphragm has to be stopped down. It is too bright or too dark for a correct exposure if the exposure signals are flashing.

Shutter priority (S)
In shutter-priority mode the shutter speed is preselected using the front control dial. Operating mode and aperture/shutter speed combination are displayed in the viewfinder and on the body data panel.

Shutter priority

The shutter speed can be selected manually if the Minolta Dynax 7xi is set to shutter-priority mode (S) where the camera will select a suitable aperture to give the correct exposure. Switching to shutter priority is carried out as described earlier. The action index will appear in the viewfinder graphic display to show the change in the sharpness of a moving subject when the shutter speed is varied. The shutter speed is selected using the front control dial. Each click of the dial increases or decreases the shutter speed by a 1/2-step increment. The action index is on the extreme right if the shutter speed is fast enough to freeze the movement the camera has detected in the subject. The index moves further towards the

If the widest aperture is flashing, a slower shutter speed has to be selected to achieve a correct exposure. It is too bright or too dark for a correct exposure if the exposure signals are flashing.

73

symbol for blur as the shutter speed is reduced. The action index only refers to the movement of the subject, and any danger of camera shake is indicated by the camera symbol on the data panel in the viewfinder.

The widest or narrowest lens aperture flashes in the viewfinder, and on the body data panel, to indicate that no aperture setting is available to make correct exposure possible with the shutter speed selected. The shutter speed needs to be faster if the widest aperture (smallest aperture value) is flashing. Conversely, a slower shutter speed is required if the smallest aperture is flashing. If the two triangular exposure signals start flashing on the data panel of the viewfinder, it is either too bright or too dark for a correct exposure. A neutral density grey filter can help if it is too bright; if it is too dark a faster lens or flash light might be the remedy. The slow speed setting **Bulb** is not available in S mode.

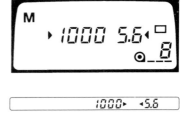
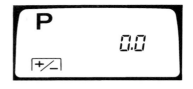

Manual exposure mode (M)
In manual mode the shutter speed is selected with the front control dial, the aperture with the rear control dial.

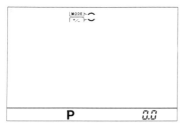

Manual exposure compensation
The exposure compensation is selected with the rear control dial after pressing the **FUNC** button.

74

Manual exposure control

If you have selected manual exposure mode (M) by turning the front control dial after pressing the **FUNC** button, you can adjust the shutter speed with the front control dial and the aperture with the rear control dial, both in 1/2-stop increments. The exposure is adjusted with the help of the triangular exposure signals in the viewfinder data panel. The tips of the triangles appear opposite each other if your selected settings will give the correct exposure. If only one triangle is visible, its tip shows the direction one of the two control dials needs to be turned to produce the correct exposure. A plus or minus sign between the two exposure signals indicates whether the selected settings would lead to under- or over-exposure. The two exposure signals in the viewfinder will flash if the light conditions exceed the metering range.

Long exposure

The standard shutter speed range of the Minolta Dynax 7xi lies between 1/8000 and 30 seconds. The **Bulb** setting is available for slower shutter speeds; this setting is reached in manual exposure mode by turning the front control dial to the left until **bulb** appears on the body data panel and in the viewfinder. If automatic focusing isn't possible, either because it is too dark or because the shooting

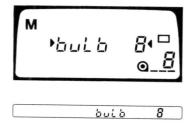

This is how you take shots with shutter speeds slower than 30 seconds: the **bulb** function is selected with the front control dial in manual exposure mode. The shutter will stay open for as long as the shutter release button remains pressed.

distance is too great for the AF illuminator, the camera has to be switched to manual focusing. In order to prevent stray light from affecting the exposure control system, once focusing has been carried out the viewfinder eyepiece should be closed using the eyepiece cover. The camera shutter stays open for as long as the shutter release button remains pressed. It is vital that the camera is mounted on a sturdy tripod for slow exposures, and it is advisable to use the remote control cable RC-1000S, or RC-1000L, in order to prevent any camera shake when the shutter release button is pressed. To connect a remote control cable, you need to remove the cover from the socket positioned underneath the expansion card door of the Dynax 7xi, and then plug it in. The camera's shutter will stay open for as long as the cable release remains pressed. The lock facility of the release button on the cable is a substantial help.

Self-timer

The electronic self-timer of the Minolta Dynax 7xi allows a delay of around 10 seconds until the shutter is released. It is activated by pressing the uppermost button inside the expansion card door, and the self-timer symbol appears on the data panel. Once composition and focusing have been carried out, the viewfinder should be closed

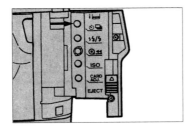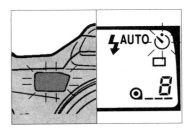

The self-timer of the Dynax 7xi is activated by pressing the top button inside the card door. The function is cancelled by pressing the button a second time.

using the eyepiece cover to prevent stray light from affecting exposure measurement. The shutter release button needs to pressed down fully to start the self-timer countdown. The AF illuminator flashes approximately twice per second during the countdown and when the shutter has been released, the self-timer function is switched off automatically. The function can be stopped during the countdown by simply setting the main switch to **LOCK**. If you want to re-activate the self-timer, press the shutter release button once more after switching the camera back on again. The self-timer function is cancelled by pressing the button inside the expansion card door for a second time.

Expert flash system

The integral flash unit and the expert flash control system of the Dynax 7xi make flash photography easier and more versatile than ever before. The expert flash system automatically achieves perfect flash shots in all light conditions. The camera offers the following flash functions: automatic and manual fill-in flash, red-eye reduction flash, and slow shutter sync. The small integral flash unit allows you to take shots at night or in very poor light conditions; but even used as a fill-in flash in backlight, it will produce technically as well as creatively superior shots in many different situations. By integrating the Program Flash unit 3500xi with the expert autofocus and autozoom systems, the camera can even offer wireless TTL flash metering. This will work even if a second photographer is working nearby with the same system. In such situations the two photographers can simply use different control channels. Older Minolta Program Flash units, such as the 2000i, 3200i and 5200i, can be integrated with the Dynax xi system, but they do not offer the interesting special functions of the new 3500xi flash unit.

In program mode the camera automatically activates the small integral flash unit, or a Program Flash unit attached to the camera, whenever this is required by the light conditions. This will occur more frequently than we have come to expect from a Dynax 7000i or 8000i. The more subtly differentiated use of flash was made possible by the fuzzy logic control system already described in detail. This system does not wait until the main subject is two stops darker than the background before it fires the flash to balance the contrast. As there are no abrupt but only finely graded transitions in the fuzzy logic control system, the expert flash system will come in earlier and will administer flash light in small, sensible doses. The small integral flash unit is popped up, charged and fired upon shutter release whenever the camera determines (depending on

Choosing the right image section is often a problem on shots of famous landmarks because the shooting position cannot be selected freely. Zoom lenses can help with picture composition.

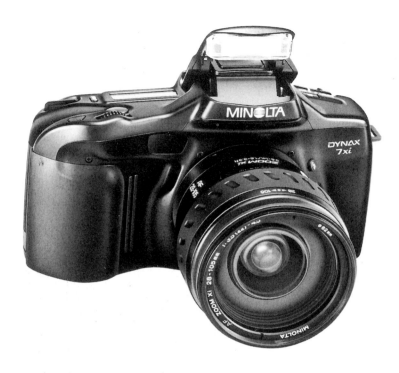

The integral flash unit of the Dynax 7xi is activated automatically as soon as the lighting conditions require flash light. It can also be switched on manually at any time.

the subject and light conditions) that additional flash light could improve the result and compensate for the different amounts of brightness in the subject. The flash unit is very cleverly built into the camera so that it is hardly noticeable at a first glance. It is surprisingly powerful for its size, managing a guide number as high as 12 at ISO 100/21°. Its coverage angle is sufficient for lighting correctly the angle of view of a 28mm lens. Thanks to the extremely fast recycling time of just two seconds, the photographer is very quickly ready to carry on shooting with fill-in flash. You don't have to wait until the automatic system of the camera detects a backlit situation, you can manually switch on the fill-in function at any time by pressing the flash pop-up button at the front of the camera. But in this case the button has to remain pressed during

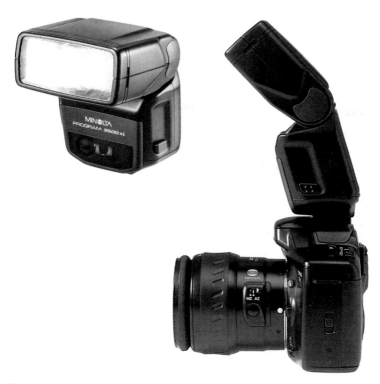

The integral flash unit can be used for wireless remote control of the new Minolta Program Flash unit 3500xi. In this case, too, flash control is based on the TTL measurement.

the exposure, otherwise the camera will only fire a flash in P mode if its expert exposure system thinks this necessary, even if the flash unit has been popped up manually. The flash is not fired in PA or PS mode. If the camera is set to aperture- or shutter-priority mode, the flash is fired if the flash has been popped up. In these modes there is no need to keep the flash pop-up button pressed in during exposure.

The shutter release button of the Minolta Dynax 7xi remains locked until the integral flash unit is fully charged, no matter which flash mode is selected. With other flashguns you can release before the unit is fully charged. The flash symbol in the viewfinder

will flash after the shutter has been released to indicate to the photographer that a correct flash exposure has taken place.

The automatic flash function can be switched off at any time, either for the next exposure only (for as long as the camera is kept on the eye) or for an entire shot sequence. In the first case you simply have to push the flash unit back down if it has popped up. The flash unit will remain switched off for as long as you keep the camera on the eye; if you put it down briefly, the flash unit will reappear if the expert flash system considers it necessary. The fill-in flash function can also be switched off completely by means of the flash mode button inside the card door.

Red-eye reduction flash

Flash portraits often suffer from the "red eye" phenomenon. This effect is caused by a reflection of the flash light from the back of the eyes. It is particularly noticeable if the flash unit is positioned near the optical axis of the lens, and when there is little ambient light, so that the pupils of the eyes are wide open. The built-in flashgun of the Dynax 7xi has a pre-flash facility by which it fires a rapid succession of flashes before the shutter opens for the actual flash exposure. This pre-flash causes the iris of the eye to "stop down" in advance of the exposure being made. The Dynax is the first AF SLR system camera to offer this red-eye reduction function. It should be used whenever you are taking portrait shots lit by the integral flash unit, but is not available with other flashguns. "Red eyes" are rare on fill-in flash.

The flash mode is selected with the flash mode button inside the card door. If you press this button you can select one of four flash modes with the front or rear control dial:

1. Flash symbol and **AUTO** for autoflash mode, if you want the camera to control flash and fill-in flash. The amount of flash light is automatically controlled in such a way as to maintain the backlit character of the subject lighting.

2. Two different-sized flash symbols and **AUTO** for red-eye reduction flash.

3. Flash symbol and OFF to cancel flash and fill-in flash.

4. Two flash symbols flashing alternately, a special function for wireless remote control of a second flash unit.

Flash functions

⚡AUTO Single flash

⚡⚡AUTO Single flash with pre-flash (red-eye reduction flash)

OFF ⚡ Flash off in P mode

⚡⚡ Wireless remote flash control with TTL metering (MC/MCI), remotely controlled TTL flash (MGB)

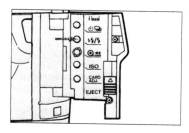 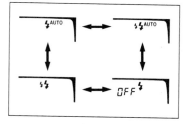

The flash functions can be selected with the front or rear control dials after pressing the flash mode button inside the card door. Four settings are available: single flash, red-eye reduction flash, flash off, and wireless remote flash control. The bottom right diagram shows the sequence of the settings.

Use of flash is not possible in PA and PS mode with creative program shift. Conversely, these two modes cannot be selected as long as the flash function display is visible in the viewfinder, that is, either until the flash unit is switched off, or until the camera decides that flash is no longer necessary.

So far we have only covered fill-in flash and automatic flash control for reducing high contrast, where the automatic exposure and TTL flash metering systems meter the exposure jointly and complement each other. But the flash is also fired automatically in very low light or in almost total darkness. But such situations are becoming increasingly rare. Total exposure by flash is almost only advisable if the fast 1/200sec sync speed is required in order to darken the background or to freeze a movement with the fast flash illumination. In this case you must set the camera to manual or aperture-priority mode. In aperture-priority you pre-select the aperture and the camera selects the fastest possible synchronising speed, and controls the flash output. You can select any aperture

available on the lens. A wider aperture allows a greater range, whereas narrow apertures provide more depth of field. The red-eye reduction flash function can be used in all operating modes, including manual exposure control.

Flash photographs with manual pre-selection of shutter speed and aperture

If the camera is set to manual mode, you can use all shutter speeds slower than 1/200sec - including **BULB** - for maximum flash creativity.

The automatic flash exposure system of the Dynax 7xi works even if you manually select shutter speed and aperture. If you have accidentally selected too fast a shutter speed, the camera will automatically ensure the correct sync speed of 1/200sec, but only with Minolta Program Flash units. Slower speeds up to 30 seconds, on the other hand, are maintained.

On focal plane shutter cameras correct flash exposure is only possible within a limited range of shutter speeds. This is because focal plane shutter cameras - which nowadays include almost all 35mm SLR cameras - control their shutter speeds by means of two curtains which allow the light to reach the film for the duration of the exposure. Particularly fast shutter speeds, above 1/200sec, are achieved on the Dynax 7xi not by opening the entire shutter, but by a small gap between the first and second shutter curtain travelling along the surface of the film, thereby allowing light to reach the surface for a very short time. This means that, on the point of shutter release, the first shutter curtain starts to move, uncovering a proportion of the film surface. With fast shutter speeds the second curtain starts to close the shutter even before the first curtain has uncovered the entire image area. But the time taken by the gap to move across the image area is longer than the illumination of electronic flash units. This means that the flash will only hit those parts of the image area which are exposed during the actual flash exposure and this results in a partial exposure. It is completely different with slow exposures. The first shutter curtain completely exposes the film, and the second curtain does not cover it up again until after the exposure. The flash can therefore light the

84

entire image area, usually as soon as the shutter has been opened. This results in a combination of ambient and flash lighting.

Slow shutter sync

Slower flash sync speeds can be achieved by precisely metering the subject background. This is desirable whenever the mood of a room or nocturnal surroundings provide the atmosphere of a shot, and the flash only lights the foreground. To achieve this, you need to aim the AF target area at the subject detail and hold the shutter release button pressed half-way; then store this measurement by pressing the AE lock button on the back of the camera. The resulting slow speed will be maintained for flash exposures while the AE lock button remains pressed. This technique results in a correct exposure for the surrounding areas, using a relatively slow shutter speed, and in a reduced flash output which correctly exposes the main subject in the foreground without destroying the mood of the shot. For this type of picture, the background needs to be slightly underexposed, but you do not need to make any adjustment to achieve this, as the camera will automatically take account of it. The slow shutter sync prevents the subject background in night shots from going black because the shutter speeds are too fast. You do not need to worry about camera shake as the flash already reproduced the main subject sharply on the film during its fast illumination period. But if you want the background reproduced sharp, you should use a tripod.

This photographic technique can be refined even further with the Dynax 7xi. The camera can remotely fire an additional flash unit, like the 3500xi Program Flash, at any time and take its output into account in calculating the correct TTL direct flash exposure. To do this, press and hold the AE lock button at the rear of the camera. Both flashes will fire to indicate the system is properly set up and working. Then take the picture, without removing your thumb from the AE lock button. It is self-evident that you have to wait until the flash unit is fully charged. The flashing symbol in the viewfinder confirms that the flash output was sufficient for a correct exposure.

In such circumstances you should try to avoid using the widest

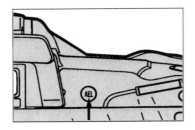

The AE lock button plays an important part in slow shutter speed sync flashing. If it is pressed, the ambient light is taken into account for the flash exposure.

aperture, and make sure that the subject background is not too bright. The camera may refuse to select a slower shutter speed if this could lead to an over-exposure of the background.

Flash photography with the Minolta 3500xi Program Flash unit

The flash techniques already described can be carried out by both the integral and the new Minolta 3500xi Program Flash unit. The 3500xi is a new, extremely versatile unit, which is totally geared to the functions of the Dynax 7xi. Remote flash control with TTL direct flash metering has been made possible for the first time with the Dynax 7xi, and the new flash unit also offers all other flash techniques for unusual flash photography. Functions available on the Minolta 2000i, 3200i and 5200i Program Flash units have been retained, and some of them have even been improved.

The TTL direct metering method on the film surface (OTF) of the Dynax 7xi always guarantees precisely exposed flash shots, no matter which flash exposure mode is used.

As soon as the flash unit is attached to the camera, the three-beam

The Dynax automatically copes with pure white with sufficient structure and similarly structured shadow parts, such as this shot of the pool of the Stelgenberger Hotel on Gran Canaria.

p 88 + 89
The image size lock function and multi-directional autofocus of the Dynax 7xi ensure sharp photos of moving subjects at a constant reproduction ratio. These are very practical aids for sports and action photographers.

autofocus illuminator and the three main autofocus sensors start to communicate, so that they can automatically activate the AF illuminator in poor light or low subject contrast. The camera calculates the flash output required for a correct exposure after focusing has taken place. It takes into account subject distance, film speed, lens aperture and subject contrast, even the autofocus calculations and autozoom settings. Two condensors are charged with the required power, one after the other. The charging process is terminated automatically as soon as these have reached the charging state required for a correct exposure. At the same time the "flash ready" symbol in the viewfinder lights up next to the flash-on indicator. In many photographic situations it is enough for just one condensor to be charged. This control system enabled the recycling time of the 3500xi Program Flash (as well as that of the 5200i, 3200i and 2000i) to be reduced by half compared to conventional flash units.

The viewfinder of the Dynax 7xi signals not only that the flash is ready, but also flashes to indicate that a correct flash exposure has taken place.

Remote flash control

Flash photography, where the camera requests and switches on the flash, works not only with the flash unit attached to the camera; for the first time it can now work by remote control. Interesting and professional light effects can be created if the flash unit is used off-camera.

The operating instructions cautiously give slight restrictions in terms of range and functionality for reasons of product liability. It is stated, for example, that the ambient light should be kept as low as possible in such cases. But as the integral flash unit substantially exceeds the range given by Minolta, it can fire the 3500xi Program Flash unit without any problems across a distance of 5m, at least in normal lighting conditions. But the further away from the subject the flash unit is, the more important it is for the additional flash unit to receive the flash signal directly.

Bright metal on a blue-black surface: the expert exposure system of the Dynax 7xi compensates automatically.

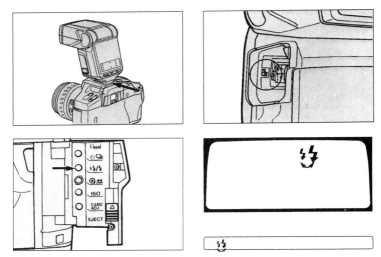

The Minolta offers two different channels for wireless remote flash control so that two photographers using the same type of unit do not interface with each other. The double flash symbol in the viewfinder and on the body data panel needs to flash for remote flash release. The setting is made with one of the control dials after pressing the flash mode button inside the card door.

Before this is done, the camera needs to be informed that remote control flash is to be used. This is done by pressing the flash mode button inside the card door and then turning one of the control dials until two different-sized flash symbols, flashing alternately, appear in the viewfinder. It is best to do this with the 3500xi mounted on the camera, since both camera and flash will then be set to remote control together.

The Program Flash unit is then set up to create the desired effect, and you need to wait until both flash units are fully charged. This is signalled by the flash symbol in the viewfinder for the integral flash, and by flashing of the AF illuminator for the external unit. This signal can be set to a different frequency for each control channel. To check that the system is fully operational, press the AE lock button at the rear of the camera. This will produce a test flash from both units, which confirms that the remote unit is responding to the control pulse. The actual exposure can then be made, as long as both flash units are once again fully charged.

To do this, the integral flash of the camera emits a start signal when the shutter is released. This signal is received by the 3500xi

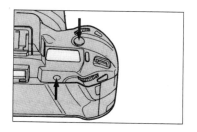 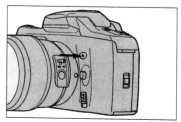

Slow shutter speed sync is also possible with wireless remote flash control. In this case a test flash is fired when the AE lock button is pressed. It remains pressed until the flash unit is once again fully charged and the exposure has been made.

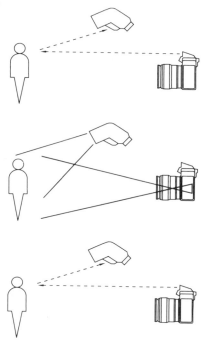

Wireless remote flash control Dynax 7xi sends a start signal

Program Flash unit 3500xi fires

Dynax 7xi sends a stop signal as soon as its TTL metering system has registered sufficient exposure on the film surface

93

within the 5m distance already stated. Having received the signal, the 3500xi Program Flash unit starts to light the subject with a series of light impulses. As soon as the TTL direct metering system of the camera has registered sufficient light on the film surface, the integral flash of the Dynax 7xi emits a second light signal in order to stop the 3500xi flash unit.

This technique can achieve many flash effects and better lighting particularly in the close-up range, for still life or portrait shots, and even interiors. As the integral flash works with the off-camera flash unit, it is also possible to control the weighting of the flash, offering the photographer further variations in terms of lighting. The flash output of the two units can be manually controlled at a ratio of 2:1. If this option is selected, the two flash units will light the subject at a ratio of 2 (3500xi) to 1 (integral flash). This creates a good fill-in effect in the foreground, and it is an easy way of achieving a perfect backlight effect or optimum background lighting. In addition, the flash coverage can be adjusted for 28mm, 50mm and 105mm focal length in remote control mode. So this type of flash technique should make it easy to achieve perfect, professionally lit results.

Two channels are available for remote control operation to avoid accidental firing if two units are used in close proximity. In order to select the control frequency, you need to mount the 3500xi Program Flash unit on the hot shoe of the camera. The desired channel for the remote control is then selected using the channel selector switch inside the 3500xi's battery compartment.

Automatic power zoom reflector

As with the Minolta 3200i and 5200i Program Flash units, the 3500xi also automatically adjusts its flash reflector to match any focal length selected. When the flash unit is mounted on the camera, the reflector is adjusted to the correct value as soon as the autozoom control system preselects a focal length. If this focal length is between 28mm and 105mm, the power zoom reflector automatically follows this setting, using data transmitted via the hot shoe contacts. Apart from providing more even illumination, this has the advantage that higher guide numbers and hence greater range can be achieved on telephoto subjects because the light is concentrated. In the close-up range, on the other hand, guide numbers and

range sometimes need to be reduced, and this is why the 3500xi is equipped with a "Low" button for reducing the flash output. This function also reduces the recycling time of the flash unit by almost half and drastically cuts down the energy consumption. For special applications or in remote control mode the reflector can be adjusted manually to 28mm, 50mm or 105mm focal length.

Indirect flashing

The flash reflector can be tilted upwards from its standard position by up to 90°, engaging at 45°, 60°, 75° and 90°. This allows the photographer to aim the flash at suitable reflective surfaces, such as ceilings or white walls, in order to achieve soft, indirect lighting without the harsh shadows often experienced with direct flash. Bounce flash is suitable for many subjects, but especially for portraits and other shots of people. You should never aim the flash at coloured surfaces for bounce flash, as their colour will also be reflected and you will end up wondering where that seemingly inexplicable colour cast came from.

AF illuminator

The integral autofocus illuminator, which is precisely aligned with the three main autofocus sensors of the Dynax 7xi, also requires power, although not very much. It automatically projects three target beams to support the autofocus system on dark, low contrast subjects. The autofocus illuminator gives off strongly concentrated, bright red light, and it has a range of approximately nine meters in complete darkness.

Guide number and output					
Guide numbers (in meters and at ISO 100/21°)					
Coverage	28mm	35mm	50mm	80mm	105mm
Output					
Output NORMAL	22	26	29	33	35
Output LOW	5.5	6.5	7.3	8.3	8.8
Range: 0.7m to 21m (at ISO 100/21° and 50mm,f/1.4 lens)					

The Minolta 3500xi Program Flash unit can also be used with the Minolta Dynax 7000i and 8000i, but the remote control function is not available with these cameras. Auto flash activation in program mode is not available with the 9000, 7000 and 5000 models.

Flash photography with the Minolta 5200i, 3200i and 2000i Program Flash units

The 2000i, 3200i and 5200i Program Flash units can be used on the Dynax 7xi with a few restrictions. But the remote control function is not available.

In order be sure flash units and camera are switched to automatic Program Flash, you simply press the program reset button when the flash unit is mounted. Normally you will not need to make any settings on the flash unit itself, except using the **ON/OFF** button if you do not want to use flash, and the 3200i has the reduced output button. The powerful Minolta 5200i Program Flash, however, has quite a few other buttons, which prove that it has been equipped with many unusual features. It has a **Menu** button in the bottom row, between the **ON/OFF** and **TEST** buttons. This allows the photographer to switch between two levels of functions. The top row of four grey rubber buttons allows the control of a variety of functions. The left-hand button (**LIGHT/MULTI**) switches on the indicator panel illumination and is also responsible for activating the strobe function for multiple flashing during a slow exposure. The **TTL-M/FREQ** button next to it is used to switch between automatic and manual mode, as well as for selecting the flash frequency for strobe flashing: 50, 30, 10, 5, 3, 2 or 1Hz. The third button (**ZOOM/REPS**) is responsible for the power zoom adjustment and for inputting the number of sequence flashes: 10, 7, 5, 4, 3, 2, or an unlimited number. The **LEVEL/RATIO** button for output control (1/1, 1/2, 1/4, 1/8 1/16 or 1/32) is on the extreme right; it is also used to control the relative output if several flash units are used, which are in this case connected by cables.

All relevant data for the flash exposure are indicated on the LCD panel of the flash unit. If you prefer your distance data in feet, you can switch from metric to imperial measures by operating a switch in the battery chamber.

Minolta Program Flash unit 5200i:
This is a powerful and very versatile flash unit for the Minolta Dynax camera.

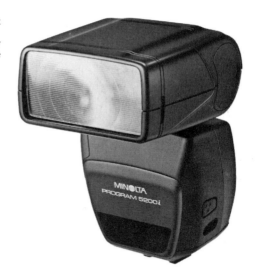

The Minolta Program Flash unit 3200i was specifically developed for Dynax cameras. All important functions are automatically controlled by the camera. The internal power zoom reflector adjusts its coverage to the angle of view of focal lengths between 28mm and 85mm.

The Dynax 5200i Program Flash unit has a guide number of 42 at ISO 100/21° and with a focal length of 50mm. Its range extends up to 30m with a 50mm,f/1.4 lens. It is supplied with power by four AA alkaline batteries or four 1.2V Ni-Cd rechargeable batteries of the same size. The batteries have a capacity of between 100 and 3500 flashes at a rate of between 0.2 and 11sec, depending, of course, on

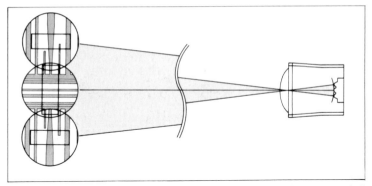

In low light the AF illuminator of the 3200i Program Flash unit projects one vertical and two horizontal patterns onto the subject as targets for the three autofocus sensors.

the shooting distance. The unit also has a connection for an external power source. This is where the external battery pack available as an accessory can be connected. The autofocus illuminator also works on the Dynax 7xi.

The reflector of the 5200i Program Flash unit has an internal power zoom which automatically adjusts its coverage angle to the focal length of the lens attached to the camera. The zoom reflector can provide optimum coverage of the image area of lenses with focal lengths between 24mm and 85mm. You can, of course, use flash with longer focal lengths, but you will then be "wasting" light. The 5200i lights the wide-angle range in the same way as the 3500xi, and is therefore clearly superior to the 3200i Program Flash unit which covers a focal length range between 28mm and 85mm. The guide number and hence the maximum range of the flash unit do, of course, change if the coverage angle is changed. It is 24 at 28mm focal length, 32 at 28mm, 36 at 35mm, 42 at 50mm and 52 at 85mm. These guide numbers apply when the flash is used with an ISO 100/21° film. But more important than these guide numbers is the option of setting the coverage angle manually (24mm, 28mm, 35mm, 50mm, 70mm and 85mm). This is useful for indirect flashing, for example if the flash light is to be reflected from the ceiling to achieve softer shadows. The reflector should be set to a shorter focal length than that of the camera lens in order for the subject to be covered completely by the reflected light, and in order to create the softest possible shadows. Practical experience

98

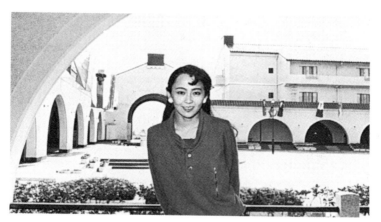

With fill-in flash

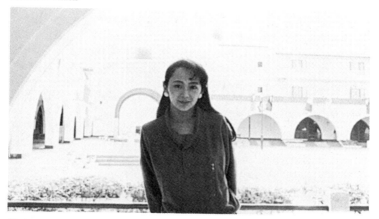

Without fill-in flash

has shown that the reflector can easily be set to a wide-angle setting two focal length values above that of the lens. The reflector can be tilted upwards and to the right by 90° respectively, and to the left by 180°.

The 5200i has an accessory socket for connecting a second i series flash unit. The **RATIO** function allows the flash output of the two units to be automatically controlled at a ratio of 1:2 or 2:1. With the relevant accessories (triple connector TC-1000) up to three i series units can be included in the ratio control function.

Macro Flash 1200AF Set-N

A very useful and even essential accessory for flash photography in the close range, the Macro Flash 1200 AF (Set N) is technically identical to the Macro Flash 1200 AF, which is available for the Minolta 7000, but includes Flash Shoe Adapter FS-1100 to enable it to be fitted to Dynax models. Its advantage, apart from fully-automatic TTL flash control, is its extremely compact construction. The four flash tubes, arranged in a square around the optical axis, can be switched on and off individually, enabling you to illuminate the subject in different ways. The flash consists of two main components - the flash head and the control unit, the latter being attached to the accessory shoe of the Dynax 7xi via the Flash Shoe Adapter FS-1100, just like any other flashgun. The flash head is attached by a special adapter ring to the filter thread of the 50mm,f/2.8 or the 100mm,f/2.8 macro lenses. The flash head can be moved around the lens for best possible illumination.

To assist focusing there is a focusing lamp at each corner of the flash head. These also help to decide on the correct framing if the lighting conditions are poor. They are automatically extinguished when the release is lightly pressed or has not been touched for 30 seconds. During the actual exposure they are switched off and they can also be switched off manually by a button at the rear of the control unit.

The Macro Flash 1200AF (Set) has four flash tubes, which can be switched on and off independently, and four modelling lamps. It allows a multitude of different lighting effects.

100

Automatic flash metering is controlled by the TTL flash control of the Dynax 7xi. Flash-ready and correct flash illumination are displayed in the viewfinder. In addition, flash-ready and confirmation that the flash illumination was sufficient, are displayed on the back of the control unit. The correct aperture settings for various reproduction ratios may be read off the table at the back of the control unit.

The Macro Flash 1200 AF (Set-N) has a guide number of 12 at ISO 100/21° with all four flash tubes switched on. The power supply is by four 1.5-volt AA-size or appropriate rechargeable batteries. For continuous operation there is a power unit that can be plugged directly into the mains.

To save energy, the flash will automatically switch itself off if the release has not been activated after about one minute. Recharging begins as soon as the release is pressed. For interval sequences with the Intervalometer Card the energy-saving function is not available.

Interchangeable autofocus lenses

You need the right lens on the right camera to make the most of your equipment. This applies more than ever to the Dynax 7xi because the expert system from Minolta can only be fully utilised if camera and lens are perfectly tuned to work together. Lenses help us to see and to make creative use of what we see. They allow us to make use of perspective, to change the relative size of things, and therefore to turn visual ideas into pictures.

The new xi lenses, with their popular focal length ranges, are perfectly tuned to work with the Dynax 7xi. Each of these small, compact zoom lenses turns camera and lens into a photographic system whose "intelligently" controlled automation goes beyond focusing and exposure, to include focal length control.

Why interchangeable lenses?

The creative possibilities of an SLR camera can only be fully utilised with interchangeable lenses. Using different focal lengths allows you to select different sections of the subject from the same shooting position without altering the perspective. By shifting the focal length you can tighten or widen the field of view.

Lenses are grouped into roughly five categories according to their focal length and special characteristics: wide-angle, standard, telephoto, macro and zoom lenses.

Wide-angle lenses are those whose focal length is 35mm or less. As you might expect, these lenses have a wide angle of view and allow shots of large subjects at short distances. The shorter their focal length, the wider their angle of view. The so-called fisheye lenses are a special group within this category and have an angle of view of 180° or more. However, fisheye lenses are characterised by pronounced barrel-shaped distortion which means that all lines not running through the centre of the image are curved.

Standard lenses have focal lengths of around 50mm. Their angle of view of approximately 45° corresponds to the perception of the human eye.

Lens-camera interconnections

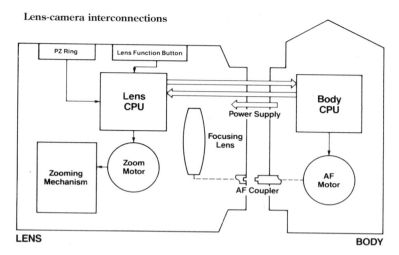

LENS

BODY

Each of the new xi series autozoom lenses, developed specifically for the third generation SLR system, has its own CPU and zoom motor. Three further contacts have been added to the electrical connections of the earlier AF lenses, allowing data to be exchanged in both directions between camera and lens, and to connect the lens to the power supply of the camera. This high degree of integration between camera and lens gives a number of advantages and new possibilities.

The telephoto category starts from around 80mm. Telephoto focal lenses allow frame-filling shots of subjects from a greater distance.

Macro lenses, on the other hand, are available in all focal length ranges. Macro lenses with focal lengths of 50mm and 100mm are available for the Dynax 7xi. They are specialist lenses for shots at close range and allow the frame-filling reproduction of small and tiny subjects.

Zoom lenses have variable focal lengths. They can be continuously adjusted to suit the photographic situation within a certain range. In recent years enormous progress has been made in the design of zoom lenses. Not only have they become smaller and lighter, but their optical qualities are now comparable to those of fixed focal lengths. They are therefore among the most popular interchangeable lenses.

The new lens program for the Dynax 7xi comprises five zoom lenses with different focal length ranges. They were developed specifically for the new Dynax xi generation, and their autozoom

and image size lock functions open up creative possibilities previously not available.

Reproduction ratio and perspective

Shooting distance and focal length determine how large a subject will be captured on film. The relationship between subject size and reproduction size is called the reproduction ratio. It makes no difference to the reproduction ratio whether a subject is photographed with a long focal length at a great distance, or with a short focal length at close range. By changing the shooting position, the photographer can use different focal lengths to capture a subject at exactly the same size. But shots of a subject taken from different distances are still fundamentally different.

A change in the shooting position is automatically accompanied by a change in perspective. Perspective controls the relative size of objects, placed at different distances in a three-dimensional subject, when they are reproduced on a two-dimensional photograph.

Used in conjunction with the xi lenses, the new image size lock function of the Dynax 7xi can reproduce a moving subject at a constant reproduction ratio, as long as the zoom range of the lens allows it. When the image size lock button on the lens is pressed, the focal length is adjusted automatically.

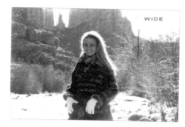

The wide view function is selected by pressing the button next to the front control dial. In this mode the Dynax 7xi, in conjunction with the xi lenses, shows an extended image section, so that the photographer can keep an eye on the area surrounding the shot. The lens returns to the actual image section at the point of exposure.

focal lengths used for wide view function

| 28 mm | 70 mm | 105 mm |

The 28-105mm Zoom xi uses focal length settings from 28-70mm for the wide view function.

focal lengths for exposure in wide view function

| 28 mm | 42 mm | 105 mm |

Focal lengths between 42mm and 105mm can be used for the exposures in the wide view function.

higher light passing capacity lower light capacity

1.4 1.7 2 2.4 2.8 3.5 4 4.5 5.6 6.7 8 9.5 11 13 16 19 22 26 32

The aperture range of the Minolta lens program lies between f/1.4 and f/32.

If the distance between subject and camera changes, the relative sizes of objects at different distances from the camera will also change. Perspective therefore doesn't depend on the focal length, only on the subject distance.

If there were no limits to enlarging negatives, telephoto shots would not require long focal lengths, we would simply enlarge the subject in the wide-angle shot to the desired reproduction ratio. It would have the same perspective as a telephoto shot from the same shooting position. The shorter the shooting distance, the more obvious the change in relative sizes will be in the shot. But this is only one of several aspects, another factor becomes obvious from the image size lock function that is new on SLR cameras.

Image size lock can be useful in many cases, when the subject is moving towards the camera or away from it. If you press the relevant button on the lens, the reproduction ratio, which is known from the focal length and the distance setting, is used as the basic data. Taking into account the direction and speed of the subject's movement registered and calculated by the camera, the lens is then adjusted so that the reproduction ratio is constant. This works across a surprisingly wide range and is so far only possible with Dynax 7xi zoom lenses.

The xi autozoom lenses

A lot has been changed on the new Minolta autozoom lenses. There is, for example, the ergonomically designed, non-slip zoom ring, which does away with the need for separate controls for focal length and focus setting.

But a lot has changed in electronic terms, too. While earlier Minolta lenses were equipped with a ROM-IC, a fixed value memory, the new lenses have been upgraded with computer technology and have their own 8-bit microcomputer which constantly exchanges data with the camera computer. Each of these new lenses also has its own zoom motor. In conjunction with the new Dynax 7xi, these new developments enable the lenses to offer a number of new autozoom functions which are not possible with the 12 earlier zoom lenses, which are still in the Minolta range and can be used on the 7xi without any loss of functions.

106

To switch off the automatic focal length preselection: set the main switch to **LOCK**, then switch the camera back on whilst holding down the zoom function button.

These new features include ASZ (auto stand-by zoom based on the subject distance) and APZ (advanced continuous program zoom on the basis of changing subject distances in conjunction with special expansion cards). Used with the Child Card, for example, APZ automatically and continuously adjusts the focal length setting when the subject is moving. This means that the reproduction ratio, and therefore the image size is controlled and kept constant.

The new zoom features also include the image size lock already mentioned, as well as the wide view function. Here the focal length is shortened until just before the exposure is made, so that the subject is shown in the viewfinder along with the surrounding area that will be outside the final shot. Minolta talks about a viewfinder image extended to 150%, visible until the shutter button is pressed. Viewfinder markings do, of course, show the actual image you will obtain on film.

Zoom lenses allow the continuous adjustment of the focal length within a certain range. They can be used to change the image size, and therefore the reproduction ratio, without any change in the shooting position. Previously, this adjustment was made manually by the photographer, and we were always advised to start with the longest focal length for focusing where possible. The experienced photographer only selected the optimum image size after focusing at the longest focal length. But fuzzy logic control brings innovation in this area, too. The expert autofocus system feeds the subject distance to the auto stand-by zoom as soon as the sensor on the viewfinder eyepiece has activated the Dynax 7xi. On the basis of this, the ASZ program selects a focal length to ensure a balance between main subject and surroundings. But as photography is also supposed to be a creative activity, the Minolta xi lenses are able

to respond to the photographer's own ideas at lightning speed. This applies to manual power zooming as well as manual focusing, which is also done using the zoom motor.

For manual power zooming the zoom ring can be turned to the right and left by up to 5°, and the zoom speed changes in proportion to the degree of the turn. This means that great changes in focal length can be carried out with the same ease as precise fine-tuning. Focal length is changed the more quickly, the further the ring is turned one way or the other. Whilst this takes some getting used to, it very quickly proves a lot more convenient than the turning and pushing we've been used to.

For manual power focusing, the non-slip focal length and focus ring is simply pulled towards the camera and turned slightly in the desired direction. As with the motor zoom, the setting speed of the motor focus varies with the degree of the turn. So you can either focus very quickly or set the focus very slowly and precisely. The final autofocus setting can easily be held and confirmed by simply pulling the zoom ring towards the camera, thereby uncoupling the autofocus system.

The new lenses combine surprisingly wide focal length ranges with compact design. The five lenses are:

AF Zoom xi 28-80mm,f/4-5.6,
AF Zoom xi 28-105mm,f/3.5-4.5,
AF Zoom xi 35-200mm,f/4.5-5.6,
AF Zoom xi 80-200mm,f/4.5-5.6 Macro
AF Zoom xi 100-300mm,f/4.5-5.6 Macro

These light, easily handled, lenses fulfil the most varied requirements, so that every Dynax photographer will be able to find a favourite among them. All the xi lenses can also achieve surprisingly large reproduction ratios, so that macro lenses are often even superfluous for shots of small subjects.

AF Zoom xi 28-105mm,f/3.5-4.5 and AF Zoom xi 35-200mm,f/4.5-5.6

The new AF Zoom xi 28-105mm,f/3.5-4.5 and AF Zoom xi 35-200mm,f/4.5-5.6 are varifocal designs with rear element focusing. Both lenses use a single compound aspherical element. The

108

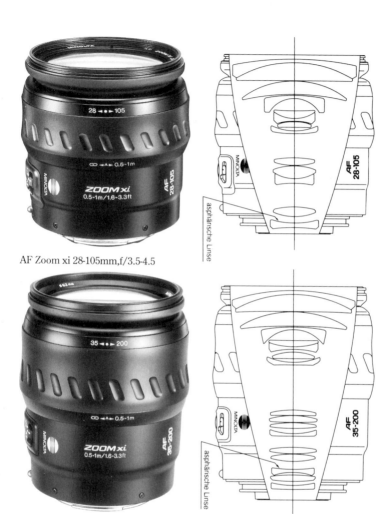

AF Zoom xi 28-105mm,f/3.5-4.5

AF Zoom xi 35-200mm,f/4.5-5.6

compact construction of both lenses owes much to the use of the unusual electronic focus compensation method. Unlike conventional zoom lenses, where the focus is kept constant during focal length adjustment by mechanical couplings, the focus is adjusted electronically. During focal length adjustment an autofocus motor simultaneously tracks the focus.

Thanks to their wide zoom range and large reproduction ratios, these two lenses can be used for a multitude of applications, ranging from close-up shots, to sports, or landscape photography.

Whilst the 28-105mm xi lens offers a speed of f/3.5 at 28mm focal length and f/4.5 at 105mm, the wider focal length range of the 35-200mm xi lens costs you a whole stop in speed. You'll hardly miss this if you always take photographs in relatively good weather, but if you like moody light in your shots, you'd appreciate the extra stop. At 450g and 500g respectively, the difference in weight between the two lenses is substantially less than the different number of elements in their optical construction would suggest: 13 elements in 10 groups, and 17 lenses in 15 groups on the longer focal length. The maximum reproduction ratio, too, is worth noting. It's 0.1 on the 28-105mm lens, and as much as 0.16 on the 35-200mm. The closest focusing distance depends on the focal length, and changes continuously from 50cm in the wide-angle setting to 100cm at the maximum telephoto focal length.

AF Zoom xi 100-300mm,f/4.5-5.6 Macro and AF Zoom xi 80-200mm,f/4.5-5.6 Macro

If you need medium to long focal lengths, these light and compact lenses are the best choice. Both are extremely easy to handle and are ideal for snapshot, sports and travel photography. The AF 100-300mm xi not only has a 3x focal length range, it can also capture small subjects on film at almost one quarter of their original size.

Weighing 440g, the 100-300mm lens is exactly 140g heavier than the 80-200mm. Despite the more complex construction of 11 elements in 9 groups used by the longer focal length lens, compared to the 9 elements in 9 groups of the 80-200, the design differences are surprisingly slight. This is also reflected by their identical close focusing distances of 1.5m. But the smaller focal length range allows the 80-200mm to be some 2cm shorter and measure in at exactly 8cm. So it is very compact, and set to become one of the most popular lenses in the Dynax xi autozoom range.

The dark blue sky and rich colours of this shot were achieved by using a polarising filter. You must use a circular polarising filter with the Dynax 7xi.

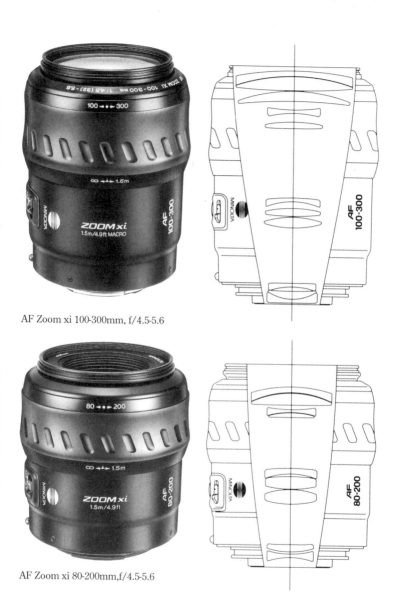

AF Zoom xi 100-300mm, f/4.5-5.6

AF Zoom xi 80-200mm,f/4.5-5.6

All Minolta AF lenses can be used with the Dynax 7xi. Focal lengths between 20mm and 24mm are needed for subjects of this type.

113

AF Zoom xi 28-80mm,f/4-5.6

Minolta expects its compact (67mm long) and light (275g) AF Zoom xi 28-80mm,f/4-5.6, with its popular focal length range, to be a standard autozoom lens for many photographers. An aspherical composite lens contributes to a compact optical design of 7 elements in 7 groups. The lens allows close-up shots up to a reproduction ratio of 1:10 and a closest focusing distance of 0.8m. It offers a zoom range from wide-angle to medium telephoto and is therefore ideal for many types of subjects, from landscapes, through groups, to portraits.

The relatively slow speed of zooms in this range means that conventional fixed focal lengths have not become redundant and in fact the opposite is more likely. If you're a fan of extreme sharpness and therefore of slow films, you are bound to find the right fixed focal length in the Minolta AF lens range. The difference in speed at 80mm between f/5.6 on a zoom and f/1.4 on a fixed focal length is four full aperture stops. In order to achieve the same shutter speed in critical light conditions you can use a film speed of ISO 50/18° with lens aperture of f/1.4, compared to ISO 800 for the f/5.6 zoom.

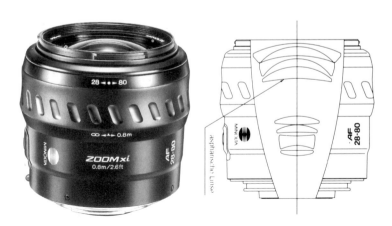

AF Zoom xi 28-80mm,f/4-5.6

114

AF Zoom lenses

Apart from the above-mentioned five new autozoom lenses, developed specifically for the Dynax 7xi, Minolta offers a further 12 zoom lenses with different focal length ranges which can all be used on the Dynax 7xi with the restrictions already mentioned. A few of these lenses are bound to be replaced by new designs at some point in the future, in order to give the camera owner full access to the convenience and technical possibilities of the xi series. But for the sake of completeness these lenses are also described in detail, as the existing range makes the Dynax 7xi the most versatile system SLR camera with autofocus.

AF 24-50mm,f/4 - The Minolta AF 24-50mm,f/4 wide-angle zoom is a real reporter's lens for capturing shots in the centre of the action at fun fairs, festivals, in marquees or interiors. It is also ideal for landscape shots or architectural photography, and the relatively high speed of f/4 ensures a reasonable flash range in poor lighting conditions. Like many of the Minolta zoom designs, this particularly compact zoom contains an aspherical lens element, which allows faster focusing as well as helping to deliver good optical performance. At a length of just 60mm and a weight of 285g, you can take it anywhere, so it is ideal for the travel photographer. The filter size is 55mm.

AF 35-80mm,f/4.5-5.6 - The smallest and lightest lens in the Minolta zoom range has a focal length range of 35-80mm, covering more than half of all average photographic situations. The range of this universal lens is sufficient for group shots and frame-filling portraits, landscapes and snapshots of children playing in the distance. In the close-up range the lens can achieve a maximum reproduction ratio of 1:6.

The integral sliding lens cap keeps the lens safe from dirt, dust and scratches. It also speeds up lens changes and prevents accidental fingerprints, finally putting an end to the search for the lens cap. The slide switch on the side ensures fast opening and closing. The two slats of the protector simply move up or down in a similar fashion to a cigar-cutter. The cover behind which the two slats disappear double as an effective stray light hood. The filter size is extremely small, allowing use of inexpensive 46mm attachments.

115

The focal length is changed with a wide ring with non-slip rubber coating. For manual focusing, however, you have to make do with a fairly narrow focusing ring without the non-slip coating.

AF 35-105mm,f/3.5-4.5 - Despite its faster speed and wider focal length range, the Minolta AF 35-105mm,f/3.5-4.5 is only 1.5mm longer and 4mm wider than the 35-80mm lens. The difference in weight is just 95g. This lens, too, has an aspherical composite lens, which is the reason why it is so compact. Its 3x focal length range and relatively high speed make it a universal lens at least for the 1000i series, and particularly versatile with its additional close-up setting. Short setting distances ensure rapid automatic focusing. The closest focusing distance is just 85cm, allowing close-up shots with a reproduction ratio of 1:6.

AF 80-200mm,f/4.5-5.6 - For 1000i series cameras this zoom lens with the classical focal length range of 80-200mm is an ideal complement to the 35-80mm zoom. It has a similar construction and the same integral front element protector. With a weight of just 290g and a length of 78mm it falls into the category of small, light lenses. It also has the small filter size of only 46mm and works in the double telezoom system, which allows particularly fast autofocusing. Its low weight and compact design make it an ideal lens for travel photography. The closest focusing distance of 1.5m allows frame-filling shots of relatively small subjects. The maximum reproduction ratio of this lens is 1:6.25(0.16x).

AF 70-210mm,f/3.5-4.5 - Despite its 3x focal length range, this telezoom is relatively fast, allowing fast shutter speeds for quick action shots with medium speed films, even on overcast days. It weighs just 420g and is only 10cm long. It has a special autofocus control button which causes all Minolta AF SLR cameras to stop the focusing process to allow the shutter to be released straight away, suspending the camera's focus-priority function. Other functions of the AF control button can be accessed with the special Customized Function Card xi for individual programming. For example, the AF control button can also be used for switching to continuous autofocus or central area AF. The filter size is 55mm, and the focal length ring is fitted with a non-slip rubber coating. The closest focusing distance is 1.1m. Magnification ratio 1:4.

116

AF 100-300mm,f/4.5-5.6 - Sports, animal and landscape shots are the strength of this telezoom with a 3x focal length range. Thanks to its sophisticated double telezoom construction, it manages to be the same length as the 70-210mm zoom, and even 10g lighter. Like the 70-210mm, it has the new autofocus control button for suspending the focus priority of the camera, or for individual functions accessed with the Customized Card xi. Its filter size is 55mm, and a closest focusing distance of 1.5m provides a maximum reproduction ratio of approximately 1:4.

Thanks to its extremely compact construction and low weight, this lens is an ideal companion especially when travelling. Used with the 35-105mm zoom, it replaces a range of five fixed focal length lenses (100mm, 135mm, 180mm, 200mm and 300mm).

AF 28-85mm,f/3.5-4.5 - (No longer current) - This zoom covers a more than 3x focal length range from wide-angle to portrait telephoto. Compared to the new Dynax lens designs, it has an extended wide-angle range, which makes it more versatile for interior shots. This versatile lens is very good for festivals and similar events, where you can cover everything from group shots to frame-filling portraits. Its relatively high speed allows fast snapshots, as well as good flash coverage with medium to fast films.

AF 75-300mm,f/4.5-5.6 - Minolta's well-proven 75-300mm telezoom has a wide focal length range that is 25mm shorter than the new 100-300mm zoom. It is the ideal lens for sports or animal photography and its expensive construction of 13 elements in 11 groups means that it is more than twice as heavy, and more than 6cm longer, than the new 100-300mm zoom. A special feature is the switch on the lens tube which allows you to limit the focusing range. It offers two positions, one for the close-up range from 1.5m to 3m, and one from 4m to infinity. This feature increases the autofocusing speed for sports, wildlife or action shots because the lens never has to travel over the whole focusing distance.

AF 80-200mm,f/2.8 Apo - The AF 80-200mm Apo zoom is a heavyweight, but a real optical treat. Its extremely high speed and a special element made of AD glass to suppress chromatic aberration give this high performance lens a special place amongst zoom

AF 80-200mm,f/2.8 Apo

lenses. Its expensive construction consists of 16 elements in 4 groups, which accounts for the weight of this fast giant. If you want to enjoy the benefits of a high optical quality lens, you simply have to carry around 1350g, not to mention the high financial outlay to acquire this exceptional optic in the first place.

Fixed focal lengths

AF 16mm,f/2.8 Fisheye - This lens has an extremely wide angle of view of 180° across the diagonal. Unlike many other fisheye lenses, it fills the entire film format. The extreme angle of view and the altered perspective, which does not correspond to normal geometric perspective, do lead to strong barrel-shaped distortion. This means that all lines not running through the centre of the image are reproduced as curved to a greater or lesser extent. The closest focusing distance of this 400g lens is 20cm. The peculiar perspective allows the photographer to create surprising effects, but fisheyes should be used sparingly as these effects quickly become tiresome. They are best suited to landscape photography or interior shots.

AF-Fisheye 16mm,f/2.8

Another feature is the integral filter turret with four filters, which are moved into position by turning a ring. The filters are integrated into the optical construction which means that a filter has to be used all the time, and explains why one of them is colourless. The other three are orange (for black-and-white and infrared shots), pale pink (for colour shots in fluorescent light) and blue (for colour shots with tungsten light when using daylight film).

AF 20mm,f/2.8

AF 20mm,f/2.8 - This extreme wide-angle lens has an angle of view of 94°, and its wide depth of field makes it versatile for architectural and landscape photography, as well as photojournalism and tight interior shots. As focusing takes place using the rear element, the close-up quality is excellent, and the speed of automatic focusing is increased. The essential lens hood supplied with the lens can be inverted for transport purposes and the closest focusing distance is 25cm. The construction of this fast 285g lens comprises 10 elements in 9 groups.

AF 24mm,f/2.8 - This compact and light 24mm lens has a slightly more moderate angle of view of 84°. It is ideal for photojournalism and snapshots, useful for landscape and architectural photography as well as tight interiors. When it comes to picture composition, particular care should be taken with the foreground in the lower third of the shot. The closest focusing distance is 25cm, and at just 215g this relatively fast lens is a real lightweight.

AF 28mm,f/2

AF 28mm,f/2 - The Minolta AF 28mm,f/2 is suitable for wide-angle shots in low light, like in twilight or poorly lit interiors. The angle of view of this particularly fast 285g lens is 75° and its optical construction comprises 9 elements in 9 groups. Its closest focusing distance is 30cm.

AF 28mm,f/2.8 - This 28mm AF lens is a whole 100g lighter and 7mm shorter, but also one stop slower than its stablemate. It is useful for the same reasons as the more expensive option of the same focal length, but it falls behind for available light photography when you want to take atmospheric shots without flash. Travel photographers, who appreciate every gram, will probably go for the AF 28mm,f/2.8 lens, which weighs just 185g. Landscapes, interiors and snapshots are the strengths of this universal focal length.

AF 35mm,f/1.4 - The AF 35mm,f/1.4 wide-angle offers extremely high speed, normally only available on standard lenses around 50mm focal length. It is an ideal standard lens, particularly suited for atmospheric landscape shots in twilight, or for shots without flash in poorly lit interiors. Its expensive optical construction of 10 elements in 8 groups make this lens relatively heavy: at 470g it is the heaviest wide-angle in the Minolta AF range. Like the AF 28mm,f/2, the AF 35mm,f/1.4 also has floating elements in its construction to improve optical quality in the close-up range. The AF 35mm,f/1.4 also has an aspherical element in its rear element focusing system, which helps image quality and reduces focusing time.

AF 35mm,f/2 - The AF 35mm,f/2 has a maximum aperture one stop smaller than the AF 35mm,f/1.4. This lens, weighing 240g, is ideal if you don't work in extremely demanding conditions, like shooting in the poorest light conditions without flash. Like its faster 35mm counterpart, this lens also offers excellent field flatness. For many photographers the weight of a lens is a decisive factor, and the reduction in speed by one stop reduces the weight by almost half, though filter thread and closest focusing distance are identical with the faster 35mm wide-angle.

AF 35mm,f/1.4

AF 35mm,f/2

Standard lenses

AF 50mm,f/1.4 - Standard lenses are wrongly becoming increasingly unfashionable. These versatile lenses are usually fast, and have an angle of view that matches the human eye. This means that many photographers find standard lenses with focal lengths around 50mm boring, but few lenses offer more possibilities than the much-maligned normal or standard. These usually very fast, compact lenses are especially useful for available light photography without flash. Conversely, their wide maximum apertures provide great flash ranges. This fast standard lens with a maximum aperture of f/1.4 even allows photography by candlelight.

AF 50mm,f/1.7 - This standard lens is still relatively fast - only three lenses in the whole Minolta range offer a wider initial aperture. It has the same dimensions as the faster lens, shares its close focusing distance of 45cm, but it is a full 65g lighter. One advantage

AF 50mm,f/1.4

of a half-stop less speed is, of course, price. High speed, low weight and low price are the main arguments in favour of a standard lens. But remember, the 50mm focal length is covered by several zoom lenses in the Minolta lens range.

Medium telephoto focal lengths

AF 85mm,f/1.4 - The super fast 85mm telephoto lens in the Minolta lens range, weighing 550g, is particularly favoured by professionals. Its high speed is suitable both for atmospheric shots in low light, and for making use of differential focus. Here the advantages of a wide maximum aperture become very apparent in portrait shots, where a cluttered background dissolves into unsharpness. Another advantage is the ability to work with fast

AF 85mm,f/1.4

123

shutter speeds even in poor lighting conditions. A so-called floating effect, where elements move in different directions relative to each other during focusing, was used in the design of this lens to improve optical quality.

AF 100mm,f/2 - Although it has a focal length 15mm longer and a maximum aperture of f/2, the 100mm telephoto lens is 70g lighter than the super fast 85mm and at 55mm, its filter thread size is exactly 17mm smaller. Which one of these two very similar lenses you go for all boils down to photographic preference. Both are excellent for portrait and landscape photography. Decide on whether you prefer the slightly longer focal length, the higher speed, or the lower weight. Price, too, will be an important factor for your decision but both the 85mm and the 100mm are top class performers.

AF 135mm,f/2.8

AF 135mm,f/2.8 - The slightly slower AF 135mm,f/2.8 is an inexpensive alternative to the shorter 85mm and 100mm lenses. It is just over one-third of their price, but weighs 365g (185g less than the 85mm lens) and is less than one centimetre longer. This lens, too, is excellent for portrait photography, and it can be used for sports and action shots over medium distances. As its closest focusing distance of 1m is the same as that of the 100mm lens, it even provides a greater magnification in the close-up range. This means that subjects smaller than an A5 sheet of paper can fill the frame.

Apochromatic lenses

Chromatic aberration is a colour fault which manifests itself in the following way. Different colours of the spectrum are refracted in different ways when passing through the lens which results in different coloured images different in size and at different positions along the optical axis. These are called magnification and focus differences, and such faults are manifested in colour fringes and unsharpness in the shot. The effect becomes particularly noticeable on longer telephoto focal lengths.

On most lenses this fault is only corrected for two colours, and this generally produces an acceptable impression of sharpness. The correction is achieved by combining several elements which cancel out each other's faults. Lenses which are corrected for two colours - usually yellow and purple - are called achromatic lenses. The combination of positive convex and negative concave elements, made from different types of glass, is usually sufficient to achieve the correction. The correction of chromatic aberration for the whole spectrum of blue, green and red is far more difficult. Lenses corrected in this way are called apochromatic lenses, and Minolta offers this type of correction in the AF 80-200mm,f/2.8 Apo and all fixed focal lengths above 200mm.

AF 200mm,f/2.8 Apo - The fast AF 200mm,f/2.8 Apo was designed for the special requirements of photojournalists and wildlife and sports photographers. Internal focusing is particularly fast and accurate, and can be speeded up even more by preselecting the focusing range. This is done by selecting the largest or smallest focusing distance via a special ring, so that focusing never travels across the entire focusing range. As you may know, the focusing movement is normally longer in the close-up range than in the far range. And so by limiting the close-up range to 5m for sports shots, the focusing speed is at least doubled. Apochromatic correction is achieved by using two elements made of AD glasses (glass with "anomalous dispersion") and as such elements are more heat-sensitive than others, the lens tube is beige to reflect heat rays more effectively than the usual black finish.

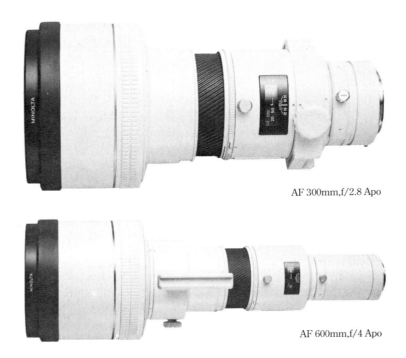

AF 300mm,f/2.8 Apo

AF 600mm,f/4 Apo

AF 300mm,f/2.8 Apo - The 300mm telephoto lens is the most commonly used focal length amongst sports photographers. A high speed, to allow fast shutter speeds, is a basic requirement as sporting events often take place in poorly lit halls and freezing fast movement is often a necessity. Like the 200mm lens, Minolta's AF 300mm,f/2.8 Apo includes two AD glass elements which give particularly good colour correction. The focusing range of this lens can also be limited. Thanks to internal focusing, where only one element group inside the lens is moved, the length of the 300mm remains constant. Its weight of almost three kilograms and the long focal length generally necessitate the use of a tripod. The heavy lens has a special tripod ring, as it could damage the camera bayonet if it were supported by the camera alone. This ring is placed in such a way that the centre of gravity is positioned perfectly even when a tripod is attached. The lens can be turned in the tripod ring for changing between landscape and portrait.

126

AF 600mm,f/4 Apo - The AF 600mm,f/4 Apo super telephoto lens is twice as heavy as the 300mm. The longest telephoto lens in the Minolta range, it is also one of the fastest of its kind. Its main uses will be in the fields of professional sports and animal photography, but because it is almost prohibitively expensive (in roughly the same price bracket as a small car), this optical delicacy will remain a rarity even among professionals. AD glasses were used in the construction of the 600mm lens, too. In addition, it has an achromatic coating which improves its colour reproduction and contrast. Like the other Apo telephoto lenses, it has internal focusing, focusing range preselection and a tripod ring.

But it's not only the photographer's wallet that is stretched to the limits by this lens, it also weighs in at 5.5kg. As hand-held shots without camera shake are impossible with this super telephoto lens, a particularly sturdy tripod needs to be added to the weight of the lens. A large, expensive front element is protected by a colourless filter, supplied with the lens along with six glass filters which slot into the lens tube. They are part of the optical construction of the lens, which means that one always has to be placed in the thread of the filter compartment. The set includes one colourless filter (Normal), one yellow (Y-52), orange (O-56), red (R-60), neutral density (ND-4X), and skylight (1B). Two conversion filters (A/R 12 and B 12) are available separately. The lens has a sturdy handgrip for easy transport and a storage case is also supplied.

AF Apo tele converters

These converters can only be used with the three Apo tele lenses. It is physically impossible to attach them to any other lens. They allow the focal length of a lens to be increased by a certain factor.

Although the loss of speed with an increase in focal length is an inescapable optical law, the AF Apo converters for Minolta Apo lenses are designed to be part of the lens construction. Like the lenses themselves, they have an integral ROM-IC, which feeds into the camera all data necessary for focusing and exposure control, including the actual aperture and focal length value. This means that the actual aperture value is displayed on the data panels of the Dynax, making manual correction unnecessary. Their computer-

designed optical construction from special glasses with achromatic coating guarantees sharp reproduction with plenty of contrast and excellent colour reproduction, even when the iris diaphragm is fully open. The AF function, too, is hardly affected by the use of Apo teleconverters. A transmission mechanism in the converter connects the AF coupling devices of camera and lens. Minolta's range includes two such converters, with factors of 1.4X and 2X.

AF 1.4X Tele Converter II Apo - The AF 1.4X Tele Converter Apo is specifically designed for Minolta AF Apo lenses with focal lengths above 200mm, and increases their focal length by a factor of 1.4. This means that the 200mm lens becomes a 280mm lens, the 300mm a 420mm and the 600mm a 840mm, with the speed reduced by one stop each time. But as all Apo lenses are very fast to start with, this does not make much difference. The converters have the same beige-coloured design as the Apo lenses, so they form a harmonious unit when used together.

AF 2X Tele Converter II Apo - The AF 2X Tele Converter Apo doubles the focal length, and is also designed specifically for Minolta's Apo telephoto lenses with focal length above 200mm. It turns the 200mm lens into a 400mm lens, the 300mm into a 600mm, and the 600mm into a super telephoto lens with 1200mm focal length. At two aperture stops the loss in speed becomes more noticeable, but thanks to the high speeds of Minolta's Apo telephoto lenses, the speeds are still quite acceptable. They compare favourably with those of the original focal lengths of other manufacturers. The 2X converter also has its own ROM-IC, which transmits all data relating to the increase in focal length to the camera computer so that the data panels of the Dynax show the actual values and

AF 2X Tele Converter Apo
AF 1.4X Tele Converter Apo

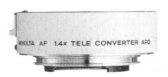

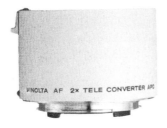

conversion is not necessary.

The high optical quality of the converter allows unrestricted use with full aperture, a fact which makes the loss in speed even more acceptable.

Reflex lens

AF Reflex 500mm,f/8 - The size and weight of very long telephoto focal lengths makes them more difficult to use, particularly for travel photography. This is why Minolta's lens range includes one real speciality, the Minolta AF Reflex 500mm,f/8, the first reflex lens for an AF camera. Reflex lenses are relatively small and light, and the Minolta AF Reflex 500mm weighs just 665g. Used on the Dynax 8000i, 7000i, 5000i and the 7xi, it focuses automatically, but on older models it has to be focused manually. It consists of 7 elements in 5 groups, including two concave mirrors which divert the path of the light through the lens. The special construction of this lens means that it cannot have an iris diaphragm, and so a filter is part of the optical construction. This also means that a filter needs to be in the compartment in front of the lens bayonet at all times.

As this lens does not have an iris diaphragm, it is always used at full aperture. The depth of field is fixed and cannot be increased in any way. The neutral density filter ND4-X supplied with the lens reduces the speed, to imitate a smaller aperture, without affecting

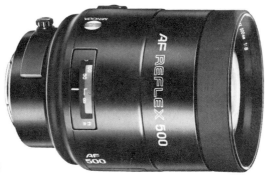

AF Reflex 500mm,f/8

the depth of field. The exposure is always determined by the shutter speed - even if the camera is in P mode.

Shots taken with reflex lenses are particularly easy to recognise if highlights or light reflections are included in unsharp areas of the shot. They don't appear as bright spots, but as bright rings or 'doughnuts', an effect which can create interesting shots. This lens does take some getting used to, but once you have discovered its appeal you won't want to do without this Minolta speciality.

AF macro lenses

Minolta offers two macro lenses of different focal length for its autofocus SLR cameras. The shorter 50mm model is suitable for copying applications, where you are working with relatively short shooting distances from the repro stand. A longer focal length, such as the 100mm lens, is to be recommended for close-up nature photography, where you have to keep your distance from the subject. Both lenses allow life size reproduction, when their largest reproduction ratio is 1:1. Which lens you go for depends on the potential application, as well as weight and price considerations. If you only take photographs of flowers - which don't run or fly away like beetles or other insects - you will be well served by the lower-priced 50mm. If you have to keep your distance you'll benefit from the telephoto macro. Otherwise, both offer the same reproduction ratio, and a speed of f/2.8.

AF 50mm,f/2.8 Macro - The AF 50mm,f/2.8 Macro can be focused continuously down to life-size at a distance of 20cm. Thanks to a special "double floating system", aberrations such as curvature of field and spherical aberration are largely eliminated. As three element groups move in relation to each other during focusing, the lens offers fast focusing as well as high speed. The closest focusing distance is defined as the distance between the subject and the film plane. As the lens tube is extended to its maximum position to achieve the largest reproduction scale, the distance between front element and subject is substantially re-duced, which restricts the ways you can light the subject. As the reproduction ratio increases, the depth of field becomes more and

130

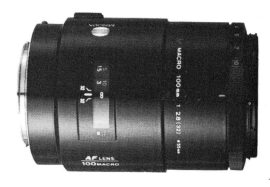

AF 100mm,f/2.8 Macro

more shallow. The Closeup Card (see chapter *Expansion cards*) provides an exposure program designed for the needs of macro photography, automatically giving preference to small apertures.

The exact reproduction ratio is shown in the position of the focus ring. The engraving 1:1 indicates actual size, 1.2 means five-sixths of actual size, and 1.5 two-thirds. It gets easier after the 2, which indicates a reproduction ratio of 1:2; three then stands for 1:3, and so on, down to 1:9, where the subject is reproduced on the film at one-ninth of its actual size. For optimum flash lighting, the Macro Flash 1200 AF can be attached to the 55mm filter thread of the AF 50mm,f/2.8 Macro.

AF 100mm,f/2.8 Macro - With the longer 100mm focal length and the 1:1 reproduction, the distance between film plane and subject is approximately 15cm greater. This has many advantages including, less problems with lighting, the smaller background area is easier to dissolve into unsharpness and most importantly, the greater shooting distance is vital for close-up shots of small animals. However, the longer focal length is also substantially more expensive, and means the lens is almost twice the price of the 50mm macro.

The sophisticated optical construction of the 100mm macro, too, includes a "double floating system", necessitating 8 freely moving elements. Three lens groups move simultaneously during focusing, allowing the lens tube to be kept relatively short.

The AF 100mm,f/2.8 Macro has the same focusing range limiter as the Apo telephoto lenses, substantially increasing the focusing

speed. For short shooting distances the focus range can be limited to 54cm, and for shots across greater distances the range can be limited from 59cm to infinity. Macro lenses generally offer excellent optical quality at a distance, making the Minolta AF 100mm Macro an excellent portrait lens.

AF Macro Zoom 3X-1X,f/1.7-2.8 - This particularly fast lens for special applications in the extreme close-up range works with limited reproduction ratios from 1:1 to 3:1.

Photography with large reproduction ratios is normally very difficult and cumbersome but a number of the settings needed are handled automatically by this AF Macro Zoom. For example, the power zoom carries out the axial movements of the front mounting, which carries the optical system, and the rear mounting that carries the camera body. The middle mounting, which should normally be attached to a tripod, remains in a fixed position relative to the subject plane. The reproduction ratio can be selected continuously between 1:1 and 3:1, and is shown on the reproduction ratio scale of the lens.

Once the reproduction ratio has been selected, automatic focusing works like with other AF lenses. The autofocus has a type of internal focusing which keeps the relative positions of subject, lens and camera body constant. If desired, the lens can also be focused manually with a knob which causes lens and camera to move together along a focusing track.

The optical construction includes floating elements to reduce spherical and chromatic aberration. The working distance of the lens is between 25.1mm (at 3:1) and 40.1mm (at 1:1).

The lens can be used with the Dynax 7xi in any automatic mode. The camera automatically compensates for the loss of light which occurs at large reproduction ratios. This means that you do not have to calculate magnification factors.

Another unique feature of this Minolta AF Macro Zoom is the motorised framing. As it is often quite difficult to precisely determine framing for magnification shots, this lens can automatically

Subjects that are difficult to get to can be brought close with a telephoto lens. A 200mm lens is sufficient for a situation such as this. Minolta offers telephoto lenses with focal lengths up to 600mm.

Minolta AF Macro Zoom 3X-1X, f/1.7-2.8

The first autofocus lens in the world for reproduction ratios between 1:1 and 3:1 (actual size to 3x magnification).

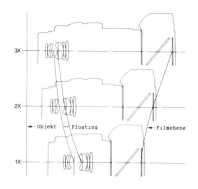

In the zoom setting, the front and rear mounts carrying the camera body and optical system move in opposite directions along the axis. The central mount, to which a tripod can be connected, stays in a constant position in relation to the subject plane. A floating element system is used to reduce spherical and chromatic aberration. In this system the distance between the two components changes in relation to the reproduction ratio.

1x *2x* *3x*

The Minolta AF Macro Zoom allows close-up shots at reproduction ratios between 1:1 and 3:1. The photos show shots with reproduction at actual size and at two and three times actual size.

An unimportant background can be dissolved into a blur by using a wide aperture. The same effect can be achieved more easily with the Background Priority Card.

adjust the camera position. By using a slide switch on the lens base (the same switch as is used for zooming) the camera body can easily be turned to the desired angle over a 135° range. The filter size is 46mm.

The power required for the zoom motor and for moving the camera is supplied by a 6-volt lithium battery, which is inserted into a battery chamber on the lens mount facing the camera body.

But all these features, plus the extremely high speed of this lens (f/1.7 at a reproduction ratio of 3:1, f/2.8 at 1:1), do have their price, and this lens is really only used for specific professional applications, very rarely by amateur photographers. This 1100g lens is supplied with an dedicated macro tripod which allows the camera/lens unit to be positioned above the subject, in a similar fashion to a microscope. The special Minolta Macro Flash 1200 AF can be attached to the front of the lens for macro flash photography. But you should remember that the autofocus may not work on predominantly red, yellow or white subjects if it is used in conjunction with the focusing lamps.

Although the speed of the lens changes with the reproduction ratio, it is not difficult to determine the exact exposure with a manual exposure meter. Unlike conventional bellows, the aperture shown in the camera viewfinder or data panel is always the actual aperture with this macro zoom.

This expensive lens is supplied with a rear and front element cover, as well as a hard case and a macro tripod.

Expansion cards

The Minolta Dynax 7xi is the fourth camera in the Dynax generation that can be programmed with additional or modified functions using expansion cards. Thirteen such cards were available before the launch of the Dynax 7xi, and a further six have now been added to allow the automatic functions of the Dynax 7xi to be programmed for unusual applications.

All these expansion cards roughly fall into three categories. The Customized Function Card xi occupies a category of its own as it can only be used for a certain camera model, in this case the Dynax 7xi. The second group includes Feature Cards which expand camera functions, and the third group is Special Application Cards.

The microprocessor of the expansion cards controls the circuits stored in them. When the expansion card is activated, data is transmitted between the main computer of the camera and the microprocessor of the card. The card influences autofocusing, exposure control or film transport depending on how it's programmed. The special software of the cards developed specifically for the Dynax 7xi has even greater influence on camera settings and includes the autozoom function new on this camera. So all cards with autozoom functions included in their program carry the xi suffix, which means that they can only be used with the Minolta 7xi or later xi camera models.

The following new cards were developed for the Minolta Dynax 7xi. Two have fully automatic functions for special applications, three expand the camera's functions and one allows numerous internal functions of the Dynax 7xi to be customised.

To activate an expansion card, simply insert one into the small slot at the top of the card door. Once fitted its functions are automatically activated and the indication **CARD** is shown in the bottom right-hand corner of the camera's data panel. The English abbreviation of the card name is shown on the data panel for approximately five seconds. If Feature Cards are used, their settings can be adjusted by pressing the **CARD ADJ.** button inside the card door. This button is only used for Feature Cards and the Customized Function Card xi. No additional setting is necessary for the Special Application Cards.

A simple numerical menu system eases the programming of the desired function modifications, and the special functions can be cancelled at any time. In order to return to the standard setting temporarily, you simply press the **CARD** button next to the data panel. This restores all the basic settings of the Dynax. If the settings of a Feature Card have been modified, the new settings remain changed on the card for future use.

A small window on the card door allows you too see which card has been inserted, without opening the card door. With most expansion cards the functional modification is only maintained while the card is inserted, but the Customized Function Card xi is again an exception. The program functions selected with this card are maintained even if the card is removed from the camera. It is therefore quite feasible for several people, for example members of a photographic club, to share such a function card. But remember that although there is such a card for the Minolta Dynax 7000i and 8000i models, the new one, the xi card, is geared specifically to the many automatic functions of the Dynax 7xi. If you are a regular customer your dealer will probably set those special functions for you when you buy the camera. This means that the automatic functions of your camera can be expanded to suit your personal needs, and adjusted to match the way you work as a photographer.

Customized Function Card xi

The Customized Function Card xi allows you to determine which settings are activated for the exposure system, exposure compensation, AF metering area and metering pattern when you press the program reset button of your camera. It also allows you to change the standard settings of seven other functions on the Dynax 7xi including frame counter, film rewind, film leader, DX memory, automatic flash, AF control button or automatic grip sensor activation. Many photographers may generally prefer such alternative settings, or want to change them occasionally to suit a particular application. The modifications are automatically transmitted to the camera memory, which means that the expansion card can be removed and exchanged for a different one.

Listed below are the different customised camera functions which only need to be selected once if you insert the new Customized Function Card xi and press the **CARD ADJ.** button for each function. You can decide, when you press the program reset button, whether the camera returns to the standard settings you have selected instead of P mode. You can select P, A, S or M mode. You can also preselect standard exposure compensation between - 4 and +4 exposure values, when push processing for example.

You can choose between 14-segment honeycomb multi-pattern metering or spot metering. You can also set the default autofocus metering area and choose whether you want to use the wide metering area (extended even further on the Dynax 7xi), or the small central metering area.

For the frame counter you can decide whether you want the camera to count up or count down. Many professionals prefer to count down because then the frame counter shows how many exposures are left on the film.

Film rewind can be programmed to take place automatically, or activated manually. You can also decide whether you want the film leader rewound into the film cassette or left outside. It is strongly advisable to select the complete rewind option, unless there is a very serious reason for not doing so. Many camera repairs are caused by the focal plane shutter being touched or even damaged when removing the film.

The photographer can also influence the DX coding with the Customized Function Card xi, switching off the automatic DX memory of the camera. But this only makes sense if you constantly alter the DX-coded speed of a film.

The automatic flash can also be switched on or off, although this means that the photographer sacrifices one of the most important new features of this unusual camera.

You can also alter the function of the focus-hold button on the AF 70-210mm,f/3.5-4.5, the 100-300mm,f/4.5-5.6, the 200mm, 300mm, 400mm and 600mm Apo lenses and the AF Reflex 500mm. Instead of locking focus, the button can be reprogrammed to select either the central focusing area, or continuous focus.

Finally, the photographer has to decide whether the eye-start sensor on the viewfinder eyepiece is to be activated by the grip sensor.

Feature Cards

Eleven different cards are now available to expand the functions of the Dynax 7xi beyond its already substantial creative possibilities. These cards turn the camera into a specialist tool, without the need for the photographer himself to be a specialist.

Three new cards are available in this group. One controls background sharpness, one is for panning effects, and one is for intervalometer control. This group also includes previously introduced expansion cards for automatic exposure bracketing, automatic program shift, automatic highlight and shadow control for spot metering, for producing average values of several spot measurements, multiple exposures, flash bracketing, storing exposure data, and for achieving special effects.

Background Priority Card

The expansion card for controlling the background sharpness allows you to determine, using the depth index of the Dynax 7xi, how sharp or unsharp the background is to appear in the shot. A particularly valuable feature of this card is the fact that the degree of background (un)sharpness selected is maintained even if the photographer takes several shots of the subject from different perspectives and with different focal lengths. All you have to do is change the aperture setting and watch the depth index. The camera will try to maintain the selected degree of background sharpness, regardless of any changes in focal length and distance.

To activate this function, the expansion card is inserted into the card door with the camera switched on. For approximately five seconds the data panel will display the abbreviated name of the card, in this case **bknd**. The word **CARD** is also shown at the bottom, next to the cassette symbol, to remind you that a card is activated. If you then press the **CARD** button next to the data panel, the function is suspended and the **CARD** indicator on the panel disappears. The same applies to all other expansion cards and the exposure functions of the camera are automatically switched to P mode. The standard settings cannot be changed when an expansion card is activated.

140

The depth index can be set to the desired value by turning the front or rear control dial when the electronic system of the camera is activated. The subject is most clearly separated from the background if the depth index is set to the extreme left of the scale. Conversely, the camera is programmed for maximum depth of field if the depth index is on the extreme right. Each marking on the scale, which shows two triangles and a portrait symbol at both ends, represents a different degree of sharpness. Pressing the release button partway down confirms the setting. But the selection is only completed in conjunction with the electronic system of the camera which confirms the value selected by the photographer if the lens used, the light conditions and the distance between lens and subject permit. If not, it indicates the next possible value and programs itself accordingly. To take the shot, you simply have to press the shutter release button.

In this function the camera does not take into consideration whether the shutter speed might cause camera shake. Program Flash units from the i and xi series are switched off if the Background Priority Card is activated. With AF Program Flash units the photographer has to switch off manually and the same applies if a macro flash unit is attached. The background priority function only works with the xi autozoom lenses.

You can, of course, help the automatic program to control the background sharpness by selecting suitable focal lengths, reproduction ratios and apertures. Long focal lengths, large reproduction ratios and wide apertures ensure an unsharp background, when the depth index is far over to the left. Short focal lengths, narrow apertures and fast films allow greater depth of field.

The Background Priority Card allows the main subject to be separated from the background. The extent of the depth of field can be determined with the depth index.

Panning Card

The Panning Card (abbreviated **pan** on the data panel) helps the photographer achieve good panning effects with fast-moving subjects. The card arranges exposure settings so that the main subject is rendered as sharp as possible during panning, while the background is noticeably blurred.

Cleverly, the autofocus system can determine how precise the panning movement is. If it is very precise, it automatically selects a slower shutter speed, which in turn increases the blurring of the background. When panning is less precise, a faster shutter speed is set to keep the moving subject sufficiently sharp.

When the Panning Card is activated, the action index appears in the viewfinder to let the photographer monitor his panning technique. The further to the right the index is, and the closer it gets to the sharp symbol of the runner, the faster the shutter speed will need to be and the less pronounced the blurred background. Usually the aim of this technique is to get the index to the left as far as possible. The photographer can help this further by selecting a longer focal length - above 100mm if possible. As the panning distance is reduced, the background, which is rendered larger than with a shorter lens, blurs more easily. Shots with blurred

The Panning Card for the Minolta Dynax 7xi allows the degree of speed blur to be determined precisely.

backgrounds are particularly effective in sports photography. The panning effect emphasises the impression of speed and movement. The problem is usually the synchronization of camera and subject movement.

Intervalometer Card

The expansion card for intervalometer control was designed specifically for time-lapse sequences of subjects such as sunrise and sunset, or flowers blossoming. This card allows the photographer to program the camera so it automatically takes up to 40 shots at intervals between one second and 24 hours apart. With the card inserted and the **CARD ADJ.** button pressed, you have to input the parameters for the intervals, number of exposures and start time.

The interval is the amount of time between the first and all subsequent exposures. It is preprogrammed to a standard setting of 0h 1m 0s and can be extended to 24h 0m 0s. The indication **InVI** is partially replaced after the **CARD ADJ.** button has been pressed. A flashing **0** and **1** appears next to the **In**, and the indications **h** for hour and **m** for minute are visible above. The hours are selected first, by turning the front control dial. You then need to press the AE lock button at the back of the camera in order to be able to select the minutes, again with the front control dial. To select the seconds, you have to press the AE lock button once more and turn the front control dial to set the desired number. The **CARD** indicator flashes during the setting process.

The indication **Fr** (frames) for selecting the number of frames appears if you press the **CARD** button next to the data panel. The flashing **1** can also be changed to the desired number of exposures - up to a maximum of 40 - by turning the front control dial. Avoid using the maximum capacity possible but limit yourself to the number of exposures available on the loaded film, otherwise you'll have to change films during the intervals.

The third parameter to be set is the start time, that is the time after programming when the camera takes the first shot of the sequence.

Having selected the last variable, you need to press the **CARD ADJ.** button once more for the whole selection to be stored

correctly in the camera's memory. You will once again see **inVI** on the data panel. If you want to change any of the settings, after setting the start time, you need to press the **CARD** button at the top of the camera rather than the **CARD ADJ.** button inside the card door, and then repeat the whole process.

The AF and exposure control systems are activated five seconds before the first exposure. If no setting in AF mode is possible, the exposure is skipped and the intervalometer program moves on to the next exposure. The program switches off automatically if the interval is less than five seconds longer than a potential slow exposure. Additional manual exposures in between the programmed exposures are not considered a disruption or interruption of the program. If a flash unit is to be used, it should be ready to function before the first exposure. If intervals of less than one minute are set, the flash will remain charged, instead of switching off between exposures, so it could be important to insert fresh batteries in the flash unit beforehand. Minolta restricts the use of the creative programs (PA/PS) as the flash does not fire in these functions. The intervalometer function is automatically interrupted at the end of a film. As the programming steps always have to be carried out in the same order, it is worth sticking a mini-checklist on the expansion card cover to avoid constantly having to refer to the comprehensive operating manual.

Exposure Bracketing Card

Correct exposure is often not a question of correct metering but a matter of taste, especially within the extended speed range of modern films. With slide films particularly, slight under-exposure can produce punchier, richer colours, while minimal over-exposure can lead to better results for examining shots on the lightbox or for enlarging on reversal paper. Even professionals rarely rely on exposure measurements and experience alone, but take exposure sequences to be on the safe side. This means that they take a number of shots of a subject, systematically varying the exposure from shot to shot. In this way they can be sure to get an optimum result every time.

With the help of the Exposure Bracketing Card the Minolta Dynax 7xi can automatically produce such exposure sequences.

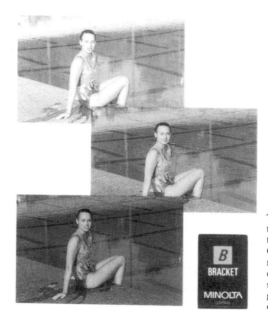

The right exposure is often a matter of taste. With the Exposure Bracketing Card the camera automatically takes sequences of three, five or seven frames with programmed differences in exposure.

This card allows the photographer to shoot automatic sequences of three, five or seven frames, whose exposures differ by either one-third, half or a full stop. The first frame is always exposed in the way the camera considers correct. Half the others are exposed more tightly, the other half more generously, by the preselected step.

When used in this way, the camera automatically switches to continuous framing mode. If you let go of the shutter release button before the bracket is completed, the camera stops and interrupts the exposure sequence. The aborted sequence is not continued when the shutter release button is pressed again, but instead, the camera starts a new sequence. Exposure bracketing sequences are not possible in single frame mode and the focus of auto bracketing sequences is locked before the first frame.

Like all other expansion cards, the Exposure Bracketing Card is inserted into the card door with the camera switched on. The abbreviation **brAc** and the standard setting of the card then appear on the data panel. If the standard setting is not changed, the display disappears after approximately five seconds. In order to switch of

the expansion card function, you simply need to press the **CARD** button; the **CARD** indicator on the data panel disappears, and the camera is once again working "normally", except that continuous framing is still set. To reset to single framing, press the **P** button, or use the selector button inside the card door.

In its standard setting the Exposure Bracketing Card is programmed for automatic exposure sequences of three frames with an exposure variation of one light value each time. To change this setting you have to open the card door and press the **CARD ADJ.** button. The **CARD** and exposure adjustment indicators will now flash to indicate that the setting can be changed. At this point the shutter release button and autofocus will remain locked.

The exposure is changed with the front control dial, in increments of 0.3, 0.5 and 1EV. When the adjustment has been made, press the **CARD** button. The **CARD** and frame number indicators will flash on the data panel. You can now use the front control dial to select the desired number of exposures - three, five or seven. To confirm your selection, press the **CARD ADJ.** button once again and close the card door. The exposure variation and number of exposures will stay in the memory until it is changed again. If programming is interrupted for more than 20 seconds, the data panel returns to the normal display, retaining the last selected settings.

Automatic exposure bracketing is possible in all exposure modes, except TTL flash control, for which a separate card is now available. In program mode aperture and shutter speed are controlled automatically. In aperture-priority mode the camera varies only the shutter speed to achieve the different exposures, in shutter-priority mode the aperture is changed. In manual mode the shutter speed is varied. If the necessary shutter speeds or apertures exceed the range of the camera, the Dynax 7xi automatically selects the nearest usable shutter speed/aperture combination available.

Automatic Program Shift Card

Unlike the Exposure Bracketing Card, where the exposure changes during the shot, the amount of light remains constant for exposures with the Automatic Program Shift Card. Only the shutter speed/aperture combination is changed. The photographer can select a shift of one, two or three exposure stops.

146

The Program Shift Card allows a sequence of three shots with preselected program shift. The aperture and shutter speed can be varied by one, two or three exposure stops.

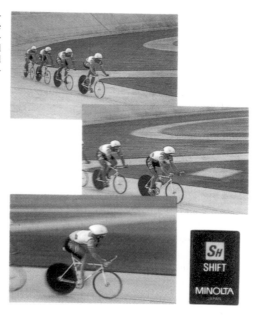

A short digression to the subject of exposure. The film needs a certain amount of light for a correct exposure. The camera regulates this amount of light with the aperture and shutter speed. If the aperture is large, a lot of light will reach the film, if it is small, it will take longer for sufficient light to reach the surface of the film. If the aperture allows only a small amount of light to pass through it, more time will be needed for a correct exposure than with a large aperture. This means that the exposure stays the same, no matter whether the required amount of light reaches the film slowly through a small aperture (slow shutter speed), or quickly through a large aperture (fast shutter speed).

The exposure meter assigns a so-called light value to every brightness level. Each light value in turn covers a whole series of shutter speed/aperture combinations, all of which are suitable for letting the right amount of light reach the film. But although all shots taken with the different shutter speed/aperture combina-

147

tions will be correctly exposed, they can have fundamentally different effects. This is because shutter speed and aperture don't just control the exposure, they are also creative tools.

Fast shutter speeds freeze movement, slow speeds allow blurred movement. Small apertures produce a large depth of field, large apertures reduce the sharpness to the focusing plane and are therefore able to dissolve the background into a blur.

By using the Automatic Program Shift Card the photographer can automatically take three correctly exposed shots, one after the other, with different shutter speed/aperture combinations. The first exposure will be taken with the standard program setting, the second with a faster shutter speed and larger aperture, the third with a smaller aperture and slower shutter speed.

The photographer can preselect the aperture and shutter speed shift in one, two or three exposure stops.

The data panel displays **SHft** and the indicator for the selected exposure adjustment. The display will start flashing if the **CARD** button is pressed, and the front control dial can then be used to change the shift. The selection is confirmed by pressing the **CARD ADJ.** button, which has to be pressed once more if the selection is to be changed again. The Automatic Program Shift Card is ideal for photojournalism, where time-consuming experiments with photographic effects are either not possible or too risky. With the Automatic Program Shift Card you don't run such risks. You can, for example, capture a skier razor-sharp with a fast shutter speed, just to be on the safe side, and then perhaps get another shot with interesting streaking effects. As the three exposures are taken in rapid succession, you don't lose any time over your experiment, and you're always certain to get an ideal shot. As with the Exposure Bracketing Card, you must remember to reset the camera to single frame after using this card.

Highlight/Shadow Control Card

All cameras assume that all subjects metered average out to a medium grey. But in reality things are quite different, life is not grey, but full of colours, and all colours have a different reflection pattern, as well as their own basic brightness. Exposure is not only

affected by the amount of light available, but also by the colour of the subject to be photographed.

If you want your Dynax 7xi to photograph a subject that is located outside the honeycomb metering area and set in front of a black background, it would consider the black background to be grey and think the subject is darker than it actually is. This is because the black background reflects less light than a medium grey would send back to the camera. As a result you would get over-exposure, which can have a particularly negative effect on a light subject in front of a dark background.

With most normal subjects, the automatic exposure system of the 7xi would compensate for such differences in brightness. But in special cases, for example with white or black subjects, over- or under-exposures can occur. On the other hand, you can use exposure to improve the mood of subjects with lots of bright colours or many dark details, and meter the exposure from the highlights. Alternatively, you can expose the shot more brightly so things appear brighter and airier, tending towards "high key". Dark subjects become more "low key" by metering from the shadows. The Highlight/Shadow Control Card used in with spot metering allows you to take the nature of your subjects into account.

The Highlight/Shadow Control Card uses spot metering to take into account the reflectiveness of the subject. The highlights and shadows appear more natural.

When the card is set to meter highlights, the Dynax 7xi automatically increases the exposure of the shot by 2.3 stops. For shadow readings the exposure is reduced by 2.7 stops.

Like all other cards, the Highlight/Shadow Control Card is activated automatically by inserting into the card door. The first line of the data panel displays the abbreviation **High** for highlight, indicating that the Dynax 7xi is ready for highlight-oriented spot metering. Shadow-oriented metering is selected with the front control dial after pressing the **CARD ADJ.** button. The first line of the data panel will now display **SHAd** for shadow. By pressing the **CARD** button, the Highlight/Shadow Control Card can also be switched off while the card is still loaded in the card door.

Multiple Exposure Card

The Multiple Exposure Card allows up to nine exposures to be made on the same frame. Although you have a choice of three exposure modes, you should spend a little time to consider multiple exposure technique.

The main problem is that the exposure setting you give each separate shot is not necessarily determined by the number of images combined, but by the number of overlapping exposures. So if you want to photograph a person in front of a dark background eight times, so they appear to be standing in line, you will need eight normal exposures. But if the separate exposures of this sequence overlap, you need to use an exposure correction. This in turn depends on the number of subject overlaps. If, for example, the person overlaps four times, each time with their immediate neighbour, you only have to make a compensation for a double exposure. But if the eight people standing in a row turn into two overlapping groups of four, the exposure has to be adjusted as if it was a four-times multiple exposure. The amount of overlapping exposures is the factor by which the selected ISO value has to be multiplied to produce the new working speed to allow automatic exposure.

Bright backgrounds should be treated as an additional multiple exposure. This is the easiest formula for multiple exposures, but in practice a negative exposure correction should be added to it. To

150

The Multiple Exposure Card can produce several exposures on one frame.

achieve successful results the photographer needs to master technique by practice, but this is not easy. The Minolta expansion card offers two simplified options which, although multiple exposures, produce a different effect.

To start with, the card always anticipates a normal multiple exposure with non-overlapping subjects on a dark background, and all partial exposures of a sequence have the same intensity, and are normally exposed as indicated on the data panel.

In fade-in and fade-out mode, on the other hand, the partial exposures within a sequence are exposed more and more or less and less, depending on the selected mode. The first partial exposure in fade-out mode and the last in fade-in mode are once again exposed normally. With this technique you can slowly make a subject visible - fade in - or seemingly make it disappear into darkness by fading out.

Flash Bracketing Card

The Flash Bracketing Card allows the camera to be programmed in such a way that it produces sequences of three, five or seven shots whose exposures differ by a half or full stop. The first exposure is always the normal, while the second and third are lit so they are over- and under-exposed either side of the normal value. This means that the main subject is exposed by a half or full stop more generously in the second, fourth and sixth exposure, while it

151

is exposed less in the third, fifth and seventh exposure. The tighter and more generous flash illumination only applies to the main subject. Here the camera makes an exposure measurement taking into account the subject background each time the shutter release button is pressed. The change in exposure is controlled by the TTL flash metering system of the camera, and the aperture and sync speed selected remain constant. In P and A mode this also works with automatic slow-shutter sync exposures, as long as you use the AE lock button to meter a specific subject detail in the background.

As this effect is achieved by controlling the flash duration, it also affects the flash coverage range. A positive correction demanding more light reduces the flash range, a negative correction increases it. If the correction is + 1/2EV, the factor to calculate the new flash range is 0.7, if it is - 1EV, the factor is 1.4. None of these changes in the flash coverage affect the closest subject distance.

In this function the camera only makes one exposure, even if it is switched to continuous mode. When you let go of the shutter release button, the new exposure and frame number are displayed for approximately five seconds. A blinking flash symbol in the viewfinder between frames indicates that a correct exposure was made. But if you release the shutter before the flash unit is fully recharged - indicated by the flash symbol in the viewfinder - the flash is not fired and the card program automatically moves on to the next frame in the sequence.

Program Flash units cannot be set to reduced **LO** output. If the output of the flash unit is too high or too low - which is possible if the camera is programmed for seven exposures in 1EV increments - a complete exposure sequence may not be possible either. This means that the 0.5EV increment is more sensible for long exposure sequences, both in terms of capacity and usually also in photographic terms. When an exposure sequence is completed, the data panel indicates **End** for approximately five seconds. The sequence can be stopped by simply pressing the **CARD** button, but if turned on again, the card will carry on the sequence from the point where it stopped. To return the card to the beginning of the sequence, it must be removed from the camera.

The Multi-Spot Memory Card can deal with difficult light situations. However, the honeycomb multi-pattern metering system of the Dynax 7xi automatically achieves a similar effect.

Multi-Spot Memory Card

Spot metering still remains the most precise exposure metering method. But the failure rate is also particularly high in this method, as it only too easy to meter from the wrong area. Spot metering requires a good knowledge of exposure metering in all situations and in all lighting conditions. The Multi-Spot Memory Card minimises this difficulty and is useful for photographers who want to create their own multi-pattern metering method for a given subject. The Multi-Spot Memory Card can store up to eight spot measurements, and the camera automatically calculates the average value and retains this value for subsequent exposures, until the card function is switched off.

Like all other cards, it is inserted in the slot at the top of the card door. The data panel displays **Spot** for five seconds, and the camera is automatically switched to spot metering.

You need to press the shutter release button half-way for focusing to take place, then aim the spot metering area at the first subject section (without further focusing), and then press the AEL metering button with your thumb to store the result. This process is repeated for each subject area you want to input. The camera immediately calculates a new average value every time, and this is displayed on the data panel as a shutter speed/aperture combination. The data panel also indicates the number of measurements already taken next to the word **Spot**.

If you input more measurements than the eight allowed, they can't be stored and so aren't taken into account. If an unwanted measurement has been taken, or if you want to measure a different section of the subject, you have to switch off the function by

pressing the **CARD** button to erase the result. The measurement can be repeated by switching the function back on.

The Multi-Spot Memory Card can be used in conjunction with P, A, S or M mode. In P mode the camera automatically selects aperture and shutter speed depending on the average exposure value and the multi-program selection which takes into account the focal length as one of the setting parameters.

In A mode, aperture priority, the shutter speed is determined automatically so that it corresponds to the average value calculated. If the preselected aperture would require a shutter speed outside the available range, the camera automatically selects an aperture which allows a shutter speed that can achieve the desired overall exposure. If this is the case, the shutter speed will flash, but will still produce a correct exposure every time. This normally automatic process can be controlled by the photographer, by adjusting the control dial. Normal shifting is also possible.

The camera behaves similarly in S mode if the selected shutter speeds would require an aperture outside the available range. Here the camera adjusts the shutter speed, and again uses a flashing warning signal. However, if possible, the camera will select the aperture required to achieve the overall exposure with the preselected shutter speed.

In manual mode (M), the camera indicates whether the values you have set are above or below the average exposure value. The exposure can be adjusted to the metered result by changing the aperture, shutter speed, or both.

This expansion card can be used with single frame or continuous advance mode, regardless of the exposure mode. But the same does not apply to the use of a flash unit because flash cannot be used with this expansion card switched on. If one of the Program Flash units is mounted on the camera, the card will only function if the unit is switched off.

The image size lock function is a practical feature of the Minolta Dynax 7xi. For example, it made sure that in the sequence of shots from which this picture was taken, the horse rider moving towards the camera was always the same size. The shot was taken with the AF Zoom xi 100-300mm f/4.5-5.6.

You should always remember that calculated average values are maintained until the expansion card function is switched off. This is particularly important if you want to take further shots, with or without a new average value.

Data Memory Card

Data records are an indispensable tool for photographers who like to experiment, so that they can precisely repeat settings they have used previously. Used with the Data Memory Card, the Minolta Dynax 7xi can record such data automatically. It can store six different parameters simultaneously, for up to 40 exposures, and call them up on command.

The following data can be stored: exposure mode; shutter speed; aperture; focal length; lens speed; and any exposure compensation. So you can experiment at leisure and recall the data when the whole film has been exposed, and take a note for subsequent analysis. You can, of course, call up the data for checking at any time. The abbreviation **dAtA** appears on the data panel to indicate that the Data Memory Card has been inserted and activated and the **CARD** indicator appears in the bottom line.

The data stored can be retrieved in three different combinations. They appear one after the other on the data panel once the **CARD** button has been pressed and the **CARD** indicator on the data panel flashes during retrieval. The first set of data displayed shows the mode used, in the top line of the panel, together with the speed and aperture in the middle section. If the **CARD** button is pressed again, any compensation used is shown in the middle of the panel. If you press the **CARD** button again, the data panel tells you the focal length used for the shot and the speed of the lens. The frame number of the exposure whose data you want to retrieve is selected with the front control dial.

Two portraits taken with the Dynax 7xi: with automatic fill-in flash (top) and with the flash function suppressed by switching to PA mode (bottom).

Travel Card

The Travel Card "rationalises" photography on holiday or when travelling. Many photographers like to have a family member or friend pose in the foreground of an interesting landscape. In such situations the manual settings necessary to ensure that the depth of field extends from the foreground to the distant landscape can often be rather time-consuming and nerve-racking. The Travel Card selects exposure combinations so that the depth of field extends as far as possible. Although focus lock is activated with the Depth Card for the Minolta Dynax 7000i and 8000i, the Travel Card automatically activates the multi-dimensional predictive autofocus of the Dynax 7xi. If you are photographing from a moving vehicle, like a car or train, the camera automatically detects movement and selects a faster shutter speed to counteract blur and camera shake.

To activate the expansion card, you need to insert it into the card door with the camera switched on. The abbreviation **trvl** appears on the data panel for approximately five seconds, and the **CARD** indicator is shown at the bottom, next to the cassette symbol, to remind you that the card has been activated. If you press the **CARD** button next to the panel, the function is suspended and the **CARD** indicator disappears.

If the Travel Card is used with an 8000i, 7000i or 5000i, the data panel indicates **dPth** for maximising the depth of field. The depth index of the 7xi is switched off, and the camera is set to the fully automatic program. Unlike the Depth Card, the Travel Card does not work with infinity, but tries to maximise the depth of field behind the metered subject, and will also use flash if necessary. This card is particularly useful with zoom lenses, when the camera works in ASZ mode (auto stand-by zoom) and will select a shorter

The Travel Card favours small apertures for great depth of field. It switches the camera to fast shutter speeds if it recognizes a movement which could lead to unsharp shots.

focal length than in the standard setting. If a zoom with a minimum focal length of more than 50mm is fitted, the shortest focal length will be set. At around 50mm, on the other hand, the camera will select the smallest aperture. Focus can be locked by pressing the shutter release button, but manual focusing or the use of the focus-lock button on a lens is not recommended.

The Child Card activates automatic control of the image section to suit the subject.

Child Card

This new Special Application Card makes spontaneous shots of children at play easier and ensures action-packed photographs. It is often all too easy to miss the best moment because you're busy setting the focal length.

With the Child Card the advanced program zoom (APZ) automatically and continuously adjusts the focal length to the subject distance, even if the subject is moving. The image size is controlled automatically to suit, enabling the photographer to concentrate fully on the subject and the right moment for releasing the shutter. This is why using this expansion card only makes sense in conjunction with one of the new xi zoom lenses. If the camera is set to continuous advance and you leave your finger on the shutter release button, three frames will be exposed one after the other. The Child Card will be available at the end of 1991.

Fantasy Effect Card

Professional photographers often use a special trick to achieve a particularly gentle, dream-like soft-focus effect; but whilst this trick is very effective, it is also quite complicated to achieve. They

159

The Fantasy Effect Card can produce wonderful soft-focus effects. Flash shots taken with this expansion card also have interesting effects.

use a double exposure rather than a soft-focus filter with the first shot taken normally, and the second taken with the lens slightly out of focus.

The effect puts every soft-focus filter in the shade, but it can only be achieved after many experiments to discover the focus shift necessary and the effects of different exposures. With the Fantasy Effect Card the Minolta Dynax 7xi can master such tricks automatically. When the card is activated, the autofocus motor of the camera automatically changes the focus during the exposure.

This in fact achieves two different effects, which are combined. The end result does depend on the depth of field. If it is shallow, with a wide aperture and a telephoto lens, you will get an enchanting soft-focus effect. Complicated double exposures and calculations of the correct exposure data are superfluous. If you want to achieve this soft-focus effect, ensure you can use a wide aperture when shooting in good light conditions, by using an ND grey filter or two polarising filters on top of each other, if necessary.

Plenty of light and the relatively slow shutter speeds selected by the expansion card result in narrow apertures and therefore a larger depth of field. As the lens has to travel across a greater distance, the soft-focus effect turns into a sort of zoom effect, a radial wipe effect. If you don't have sufficient light for this effect, it is worth changing to faster film material.

A slightly different result is achieved if the flash unit is used at the same time. The 3500xi, 3200i, 2000i, 5200xi, or built-in flash unit has to be switched on manually, as they are normally deactivated by the Fantasy Effect Card. The flash freezes the subject within its range, but the background clearly shows the radial wipe effect.

Although the Minolta operating instructions discourage the use of the Fantasy Effect Card with backlit subjects, you shouldn't let this discourage you. Try two shots, with wide and narrow aperture, to gain subsequent soft-focus and zoom effect.

Program shift is not possible, the fantasy effect cannot be used in the macro range of zoom lenses, and any restriction of the focusing range should be cancelled.

When the Fantasy Effect Card is activated, the data panel displays the abbreviation **FAnt** for approximately five seconds. The **CARD** indicator appears at the bottom of the panel and stays there as a reminder that an expansion card is activated.

It the subject range is too dark or too bright, **Lo** or **HI** will flash on the data panel to indicate too little or too much light, and the shutter release button is locked. If you can't get more light or tone things down with filters, this problem can usually be solved by using film material with a different speed.

Special Application Cards

These cards influence the basic exposure programs, the autofocus function and the film transport to tailor the camera's program mode for specialist requirements.

Sports Action Card

If you want to avoid speed-blur on sports and action shots, you will need fast shutter speeds, as well as fast reactions. If you don't want

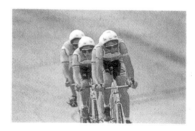

The Sports/Action Card switches the camera to program mode with fastest shutter speeds, in order to prevent speed blur.

to miss the decisive moment, you need to be ready to shoot at any time, which means there's usually no time for lengthy shutter speed and aperture setting. Whether you want to catch a high-jumper going over the bar or a bird in flight, a surfer on the crest of a wave or a horse in mid-gallop, your concentration on the right moment to release the shutter should never be disturbed by thinking about exposure settings. In such situations the Sports Action Card is a useful tool.

This card switches the Dynax 7xi to a program mode with a preference for fast shutter speeds that takes into account subject distance and focal length. This means that the automatic system prefers an extremely fast shutter speed for large magnifications, but as this decreases, the shutter speed will become noticeably slower. The **CARD** button is therefore used to switch to P mode with fast shutter speed preference. The program shift is switched off and the continuous autofocus is permanently activated so that it can follow the movement at any time. Manual focusing is possible in this operating mode, but it is definitely not advisable.

Another feature of the Sports Action Card is that it automatically switches off the flash unit. If flash is to be used, it has to be switched on manually, using the main switch of the flash unit. But even in this case the flash will only fire on poorly lit subjects. The suppression of the automatic flash seems very sensible, because fill-in flash would automatically switch to the required sync speed of 1/200sec, too slow for sports and action shots. Another factor is that most sports and action shots are taken from a distance far in excess of the flash coverage range. Other automatic exposure programs cannot be used with the Sports Action Card.

When working with the Sports Action Card, it is advisable to use faster films to enable the automatic program to select the fast shutter speeds required for freezing movement.

When the Sports Action Card is inserted, the data panel will display the abbreviation **SPrt** and the **CARD** indicator showing that the card is activated. No further settings are necessary. You can return to the standard setting of the camera at any time by pressing the **CARD** button, and the special functions of the card are cancelled when it is removed.

Closeup Card

The depth of field is reduced as the macro ratio is increased, that is, the greater the ratio between the subject's actual size and the size at which it is reproduced on film. The Closeup Card for the Minolta Dynax 7xi takes this fact into account and the card controls the aperture so that optimum depth of field is always guaranteed.

When the expansion card is activated, the camera is automatically switched to the automatic program. The AF control system is set to standard mode, without predictive autofocus. The letters **CLOS UP** on the data panel indicate that the card has been activated. Switching to a different exposure mode is not possible with the Closeup Card. Unlike the Travel Card, which automatically maximises depth of field, this card does not shift the focus to achieve a greater depth of field in the background. Instead, the depth of field is entirely extended by selecting a smaller aperture. The shutter speed is selected so that hand-held shots without camera shake are still possible, which seems sensible for autofocus close-up shots.

By selecting the smallest possible aperture in program mode the Closeup Card ensures the great depth of field required for close-up shots.

When the Portrait Card is used the automatic program of the camera selects an aperture which provides sufficient depth of field for the subject, but makes the background appear as unsharp as possible.

Portrait Card

Like the Travel Card and the Closeup Card, the Portrait Card is designed for optimum control of the aperture depending on the shooting distance. But unlike the other two cards, the Portrait Card keeps the depth of field as shallow as possible, so that a sharp subject is clearly separated from its out-of-focus background. When working close to your subject on the other hand, the aperture will automatically be stopped down to maintain sufficient depth of field for eyes, nose and mouth. This is why the shutter speed is always selected automatically, taking into account the magnification and the focal length of the lens used. It also ensures that hand-held shots can be taken without any risk of camera shake.

If the Portrait Card is inserted, the data panel shows the abbreviation **Port** and the **CARD** indicator. While the Portrait Card remains in the card door, its special functions can be switched off by pressing the **CARD** button.

164

System Accessories for Dynax 7xi

Eyepiece Corrector 1000

Although the Dynax 7xi sets the focus automatically, photographers who wear spectacles often have problems assessing the picture through the viewfinder. For this reason Minolta offers nine

Eyesight correction lenses between -4 and +3 dioptres are available for the Dynax 7xi. They can be a great help to spectable wearers who prefer to work without their glasses.

eyepiece correction lenses with values between -4 and +3 dioptres for the Dynax 7xi. These lenses snap into the camera's eyepiece.

Viewfinder Magnifier Vn and Anglefinder Vn

Viewfinder Magnifier Vn enlarges the central viewfinder section 2.3 times and is particularly useful when using manual focus for

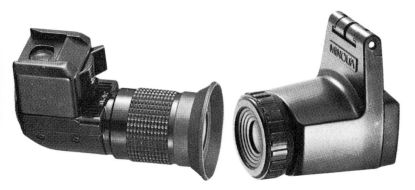

Anglefinder Vn and Magnifinder Vn

macro shots with the camera on a tripod. The magnifier may be folded up to allow the whole frame to be viewed.

Anglefinder Vn can be used for viewing from above, below, or either side of the camera. The image remains laterally correct in any position. It is also indispensable when using the camera on a copying stand. For exact assessment of the viewing area it also offers 2 times magnification of the central section.

Remote Cord RC-1000L and RC-1000S

Instead of the conventional cable release the Dynax 7xi uses a remote release which responds to electrical impulses. To use this facility you will need Remote Cord RC-1000L (5m) or RC-1000S (50cm). Both have a push button to activate the release. The cable is attached to the camera via a three-pin plug and the terminal is concealed behind a cover below the card door. The small cover can be kept safe in the cut-out of the hand unit of the release cable. A

The remote control cables
RC-1000L and Rc-1000S

remote release cable may be needed to prevent camera shake for long exposures or macro shots from a tripod. Pressing the release switch in the hand unit will activate both the autofocus system and the exposure metering of the Dynax 7xi. The remote release works in the same way as its cousin on the camera itself, apart from the fact that it also has a catch for keeping the shutter open in the **BULB** setting. When the release is in this position a red marker becomes visible, indicating that the shutter is locked open. To close the shutter, the release button has to be unlocked. Take care that the red marker is not visible when attaching the cable, otherwise the shutter will be released.

Wireless Controller IR-1N (Set)

It is also possible to trigger the shutter release of the Dynax 7xi by a wireless remote control. To do this you will need the Wireless Controller IR-1N Set. This unit is identical to the Wireless Controller of the Minolta 7000.

The Wireless Controller IR-1N (Set) allows wireless remote control over a distance of up to 60 metres. Up to three cameras can be can be controlled independently via three channels.

Since the receiver unit cannot be attached directly to the Dynax accessory shoe it should be connected to the bracket supplied with the Set, which fits between the camera and tripod. Alternatively, Flash Shoe Adapter FS-1100 can be used. In addition, the receiver has to be connected with a cable to the remote release socket.

The transmitter and the receiver each have three channels, allowing the simultaneous control of any number of cameras in up to three individual groups, if each camera is fitted with a receiver. This type of remote release is necessary if larger distances have to be bridged, or if it is impracticable to have too many trailing cables between the various units. The camera must be pre-focused, either manually or automatically, since the autofocus mechanism cannot be triggered by the infrared release.

Filters and other Lens Attachments from Minolta

UV Filter - Film emulsions tend to react strongly to UV radiation and give distinct blue hues and a loss in sharpness. Strong UV radiation is often found in mountains or near the sea. However, UV-absorbing filters are completely colourless and absorb no visible light, so they do not influence the exposure in any way, and are often kept on the lens to protect the front element.

Skylight Filter 1B/1A - These filters produce a slightly warmer colour rendering. They suppress blue for subjects in open shade, without direct sunlight, which reflect the blue of the sky. They also result in warmer colours in dull and hazy conditions. The 1B filter has a slightly stronger effect than the 1A.

Conversion filters - These filters are used to match colour film to the temperature of the illumination to give the correct colour balance. Filter type B12 (blue) is used to suppress the red bias when you use daylight film with tungsten light. Filter R12 (red) is used when a tungsten film is exposed in daylight to counteract the heavy blue bias.

Polarising filters - These remove reflections from non-metallic surfaces at certain angles. A shot taken with a polarising filter usually has stronger colours and clear sky is a deeper blue. The effect of the filter can be varied by turning it when looking through the viewfinder. The strongest effect on a blue sky occurs when the camera is pointed 90° away from the direction of the sun's rays.

There is one problem when using polarising filters on an AF lens. The front barrel of some lenses rotates during focusing, which means that the polarising filter is turned as well. The filter therefore must be adjusted after correct focus has been set so it may be better to change over to manual focusing when using a polarising filter. Alternatively, filter holders (available as accessories) enable the front element to move freely.

The autofocus system and the exposure metering of the Minolta 7xi will only allow circular polarising filters to be used. Linear polarising filters significantly affect the AF and exposure metering of the camera, and are not recommended.

168

Neutral density filter ND-4X - These special filters are neutral grey and do not affect the colour rendering. They are used in colour and black-and-white photography if the light is too bright, and to enable wide apertures or slow shutter speeds to be used in bright conditions when you want to achieve special effects.

Filters for black-and-white photography - Minolta offers four filters of this type - yellow, green, orange and red. Yellow improves the reproduction of blue sky and clouds. Green also darkens blue sky and lightens the greens of grass and foliage. Orange is often used for landscapes. They produce dark dramatic skies.

Red filters have a similar but even more intense effect and the blue of the sky appears very dark. Red filters are also used for infrared photography. The high density of some red filters could affect the AF system of the Dynax but you should experience no problem with the Minolta R60 filter. Since all colour filters absorb light to varying degrees, the exposure must be increased to compensate for this. However, this is automatically taken into account by the TTL exposure control of the Dynax 7xi.

Gelatin filter holders - Kodak offers 7.5x7.5cm light-balancing filters. These adjust the colour temperature of the illumination to the colour sensitivity of the film emulsion and are clamped in special Minolta filter holders, which are screwed into the filter thread of the lens.

Minolta Portrayer filters - As the word "Portrayer" may already suggest, these are soft-focus effect filters used for portrait photography. Minolta offers two types to give different effects.

S1 and S2, supplied as a set, are intended for general soft-focus photography with lenses of focal lengths between 50mm and 210mm. P1, P2, and P3, also available as a set, give particularly flattering portraits. This filter type has a special softening effect on skin tones. They are distinct from other soft-focus filters because the aperture setting doesn't influence the softening effect but the focal length of the lens, on the other hand, plays an important role. This makes these filters particularly useful in the program mode, when the aperture cannot be controlled manually. The soft-focus effect increases with increasing focal length. If a strong soft-focus effect is desired, more than one filter can be used.

Achromatic close-up lenses - These are used to decrease the close focusing distance and thereby increase the magnification ratio. The Minolta versions consist of two cemented elements which are screwed into the filter thread of the lens. Compared with simple close-up lenses, achromatic lenses give a much better quality of reproduction. At f/8 and smaller, reproduction quality is very acceptable - larger apertures are not recommended.

Minolta offers three lenses with different magnifications which can be combined to obtain different magnification ratios. Always attach the close-up lens with the smaller number first. The autofocus system is not adversely affected through the use of these attachments, but it is important to stay within the possible focusing range.

They are available in 49 and 55mm filter thread sizes. They are identified as 0 for +0.94 dioptres, 1 for +2.0 dioptres and 2 for +3.8 dioptres.

Lens hood - This is a very useful and almost indispensable accessory. With some Minolta lenses the hood is already built-in, but others are supplied with a separate clip-on or bayonet-fitting hood. They prevent light entering the lens from an oblique angle, which can refract and scatter inside the lens. The effect is poor contrast and an impression of unsharpness. Lens hoods are another means of ensuring good quality pictures and are a simple, relatively cheap and often underestimated accessory.

Slide Copy Unit 1000 and Macro Stand 1000

Minolta offers two accessories specially designed for the production of high-quality slide duplicates or copy prints. The Slide Copier 1000 and the Macro Stand 1000 can be used on all Dynax AF SLR cameras in conjunction with the AF 50mm,f/2.8 Macro, the AF 100mm,f/2.8 Macro and the AF Macro Zoom 3X-1X.

Slide Copy Unit 1000 - This useful and practical device has a 35mm slide holder above an opaque perspex screen which ensures that the slides are evenly lit. The original slide can be moved inside this holder easily, yet very precisely, by turning setting knobs to adjust its vertical and horizontal position in order to achieve perfect cropping. The slide copier is mounted on a special stand, designed

so that the flash reflector of the Macro Flash 1200AF can be attached quickly and easily.

This special macro flash unit is an excellent light source for evenly lighting the original slides. The Slide Copy Unit 1000 can easily be used in conjunction with the tripod of the AF Macro Zoom 3X-1X,f/1.7-2.8 when this lens is used.

Macro Stand 1000 - The Macro Stand 1000 is a practical, easily operated accessory for shots with the Minolta AF 50mm,f/2.8 Macro and the AF 100mm,f/2.8 Macro. The tripod socket of the camera body is connected to the adjustable arm fitted to the rigid tube. The baseboard with its integral translucent subject table helps you to arrange and position the subjects to be photographed. Used in conjunction with the Slide Copy Unit 1000, this device allows fast and easy shots at a macro ratio of 1:1.

The Macro Stand and Slide Copier, used with the Dynax 7xi and a suitable macro lens, allows the simple duplication of slides.

Quartz Data Back QD-7

The back cover of the Minolta Dynax 7xi can be exchanged easily. This is done by first opening the card door, then the back cover, and by pushing down the silver pin at the top right-hand side of the hinge. The standard back cover can now be removed and the data back attached. To do this, you need to hook the lower pin into the slot in the camera base and position the data back, with the pin pressed down, so that the pin can snap into place at the top. The Quartz Data Back QD-7 allows the date or time to be imprinted in the lower right-hand corner of each shot. This can be done in several formats: month/day/year, day/month/year, year/month/day or day/hour/minute.

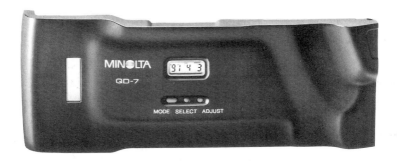

Panorama Adapter Set

Since the first throw-away panorama format cameras came on the market, more and more photographers are becoming interested in unusual shots using this format. As a result, Minolta now supplies a Panorama Adapter Set for its Dynax series cameras.

The most important component of this set is a simple mask which changes the camera's 24x36mm image section in the film plane to

the 13x36mm panoramic format. As the panoramic mask crops the negative at the top and bottom, its height is almost halved. The entire Dynax accessories range including all the autofocus lenses and expansion cards can, of course, be used for panoramic photography. The set includes a metal mask which goes between the film guide tracks, exactly behind the shutter and in front of the film plane. This mask is inserted easily and quickly with the help of the special tool supplied. While the special focusing screen 7 has to be inserted to mark the panorama image section on other Dynax cameras, the panoramic area is automatically indicated in the graphic display of the Minolta Dynax 7xi as soon as the adapter is installed. All the usual function displays are, of course, still clearly visible in the viewfinder. If you are taking panoramic shots on colour negative film, these have to be specially marked for "panoramic processing" by the photo lab. You will then get dramatic 9x25cm format stretched pictures.

Panoramic shots are particularly easy and effective when taken with the 24mm lens with an angle of view of 74° in the horizontal and 52° in the vertical. This super wide-angle lens gives a strong impression of space, particularly if the photographer has given some thought to foreground composition. As almost 45% of the film format is cropped and remains unused, you will lose a good half a centimetre in height at the top and bottom. But fortunately the parts of the image cropped are the areas most photographers struggle with. Slide photographers need special frames for panorama photography, such as those supplied by GEPE and other frame manufacturers. Panoramas are particularly impressive in slide projection and they should be projected as large as possible.

A few practical tips are useful with slides. It can, for example, be very helpful to leave the 24mm lens on the camera permanently and check the first shot with the panoramic area on the focusing screen, without the mask in the camera. The brackets enclosing the wide AF metering area of the Dynax 7xi can be used as a rough guide. After all, you can easily take the shot in the full 35mm format and create the panorama effect afterwards, by using a slide frame mask. This technique is particularly useful when travelling, when you don't have a second or third camera to use exclusively for panoramic shots. If you've only got one camera, you're running the risk of only finding telephoto subjects for hours on end, and being

If the panorama mask is inserted into the Dynax 7xi, the graphic display of the camera automatically shows the new image section.

forced to photograph them as panoramas. If your photo lab is amenable, you can also use this technique for negative films, mixing standard shots and super wide-angle shots on one film.

Storing and caring for the Dynax 7xi

The Minolta Dynax 7xi is a valuable precision tool, crammed full of the most modern electronics and precision engineering. You should always handle it with care. While the high-quality plastic body can cope with the odd rough blow, shocks, high humidity and dirt can adversely affect the functioning of the camera. So you should always protect your camera against such environmental factors. A lens hood is a good protection for the front element of the lens. It protects the glass surfaces against fingerprints and scratches, as well as improving image quality. When the camera is not used, you should always fit a lens cap.

Strong heat and high humidity are the enemies of every electronic system, so your camera should be stored in a dry place and at normal temperatures. The glove compartment or boot of a car parked in glaring sunshine completely unsuitable.

Certain fumes and chemicals can also damage the camera body and its electronic system, and you must never oil or grease any camera component. The same does, of course, apply to lenses. The shutter curtains of the camera are particularly sensitive, and you should always be careful not to touch them when loading film.

Compressed air is unsuitable for cleaning precision instruments such as the Dynax 7xi. It swirls the dust around rather than blowing it away, and the stream of air directed into the interior of the camera could change some of the settings inside the camera. A fine dust brush is still the safest cleaning tool. A dry, soft cotton cloth, possibly impregnated with silicone, is best suited for cleaning the exterior of the camera and lens. But such a cloth should not be used for cleaning the glass surfaces, which are best treated with the dust brush. If necessary, you may need to get special lens cleaning tissues or cloths from photo dealers. If the lens glass surfaces or the viewfinder eyepiece are heavily soiled, you may need to use a liquid lens cleaner. Such cleaners must be applied to the cleaning cloth sparingly, they must never be applied directly to the glass surface. If soiling is very heavy, it is advisable to have the camera cleaned by an authorised Minolta service agent.

If you want to store the camera for a longer period of time, you should rewind and remove any film still in the camera and then take

out the battery. The camera is best stored in an airtight container, together with some silica gel to absorb any humidity. Silica gel is available from pharmacies. Damp silica gel can be dried in the oven and re-used. This absorbent material is particularly indispensable for longer periods in humid climates, such as the tropics. When the camera is to be re-used, you should check all camera and lens functions before taking any important shots.

The LCD displays of the data panel and the program and data backs of the Minolta Dynax 7xi will normally function at temperatures between -20° and +50° Celsius. At temperatures below this minimum the contrast and speed of the displays will change, and the data may become difficult to read. At particularly high temperatures the data panel may temporarily go black so that the displays are invisible. But the displays will recover at normal temperatures and will once again function perfectly. If the camera malfunctions you must never attempt to repair it yourself. Instead, you should either send it to the nearest Minolta service agent or take it to a Minolta dealer. It is a good idea to keep the original packaging of the camera, so that it can be packed securely for dispatch. To save unnecessary expense, you should telephone the nearest Minolta service agent before posting the camera. The camera may just have locked because of an operating error, and often you can get it going again by simply removing and re-inserting the battery. For example, electronic circuits can switch themselves off, even though a battery with sufficient capacity is in the camera. In such cases you may only need to take out the battery and put it back again for the camera to resume normal operation. Minolta recommends that the camera should be cleaned and checked annually by an authorised Minolta service agent, especially if it is used frequently.